THE ART OF
Digital
Wedding
Photography

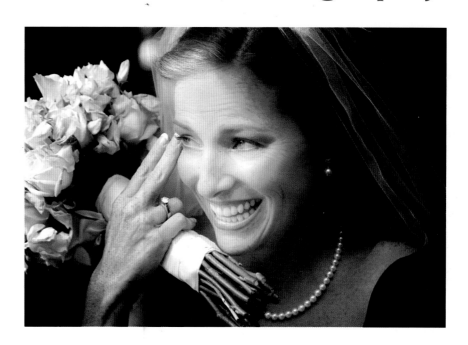

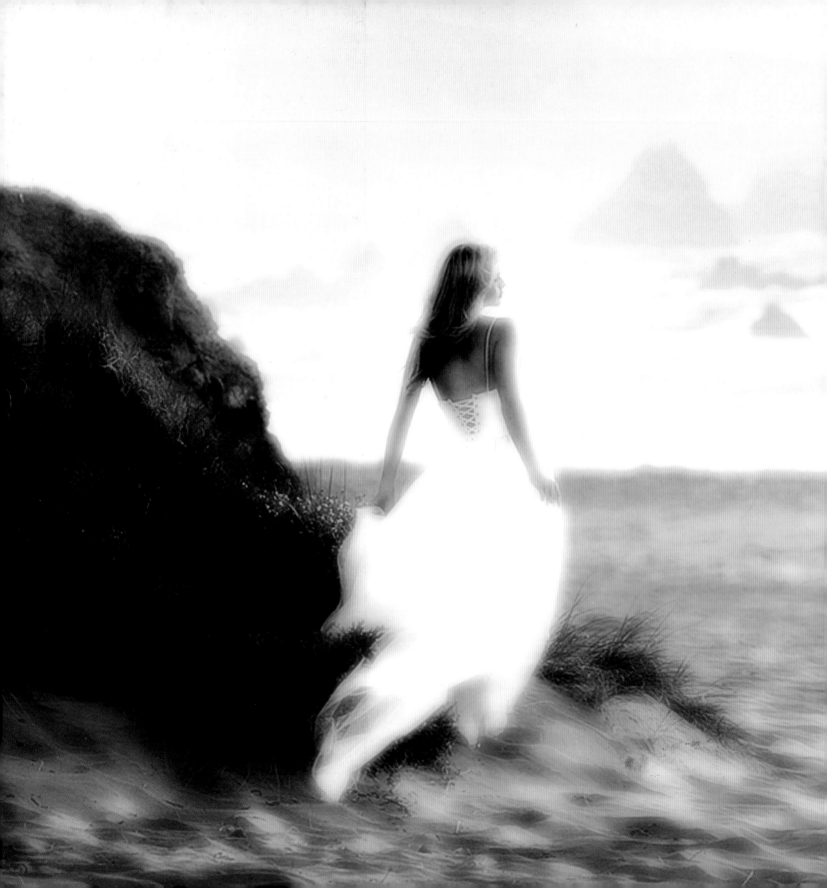

THE ART OF

Digital Wedding Photography

PROFESSIONAL TECHNIQUES WITH STYLE

BAMBI CANTRELL

AND SKIP COHEN

AMPHOTO BOOKS

AN IMPRINT OF WATSON-GUPTILL PUBLICATIONS/NEW YORK

We dedicate this book to our mutual good friend Terry Deglau.
You've set the standard for support, friendship, encouragement,
and photographic education. Like so many other professional
photographers today, where would we be without you?

First published in 2006 by Amphoto Books
An imprint of Watson-Guptill Publications
A division of VNU Business Media, Inc.
770 Broadway
New York, NY 10003
www.wgpub.com
www.amphotobooks.com

Senior Acquisitions Editor: Victoria Craven
Senior Developmental Editor: Stephen Brewer
Designer: Areta Buk/Thumb Print

Library of Congress Control Number: 2005922105

ISBN: 0-8174-3324-4

Printed in China
1 2 3 4 5 6 7 8 / 13 12 11 10 09 08 07 06

ACKNOWLEDGMENTS

The truth is, this book would never exist if it was just up to the two of us. So, where do we start to thank people for their support?

Our first big thanks goes to our families for sharing the passion and allowing us the obsession. Photography isn't a vocation or a hobby, but a wonderful sickness. Once you're hooked you never stop looking at the world through a viewfinder or an LCD, and our families have patiently gotten used to this fact. So, Steve, Cameron, Debbie, Jaime, Dane, Adam, Lisa, Zachary, and Luke—you're our biggest fans, critics, and best friends. Like our first book, this one wouldn't have happened without your confidence and support.

Book projects just don't happen overnight. They're the result of years of influence and experiences shared with other photographers. We want to extend a special thanks to Tony Corbell, Michael VanAuken, Eddie Tapp, Bill Hurter, Steve Sheanin, David Anthony Williams, Yervant Zanazanian, and Don Blair (Big Daddy, you might no longer be with us, but your influence is stronger than ever!).

The toughest thing about doing a book involving digital photography is staying on top of the new developments that come along every day. Canon and Dave Metz's team continue to set the standard and provide us with the tools we need to create incredible images. And, no digital image would be complete, let alone exist, without Adobe Photoshop. Thanks to Addy Roff, Julieanne Kost, and other members of the Adobe team. The tools available to photographers have never been better!

When it comes to printing you need consistency. Nobody does it better than Buckeye Color Lab. Job to job and print to print, the only thing more impressive than your work is the enthusiasm and support of your staff. For those moments when printing on location and in the studio, Epson has allowed us to maintain a high standard with instant fulfillment when we need it most.

Virtually all of the images in this book were created at real weddings. To all our brides and grooms: thank you for allowing us to come into your hearts and share these precious moments.

Last but not least, thank you to all those photographers and members of the WPPI and Rangefinder magazine teams who, as pioneers in imaging, have helped blaze the trail before us.

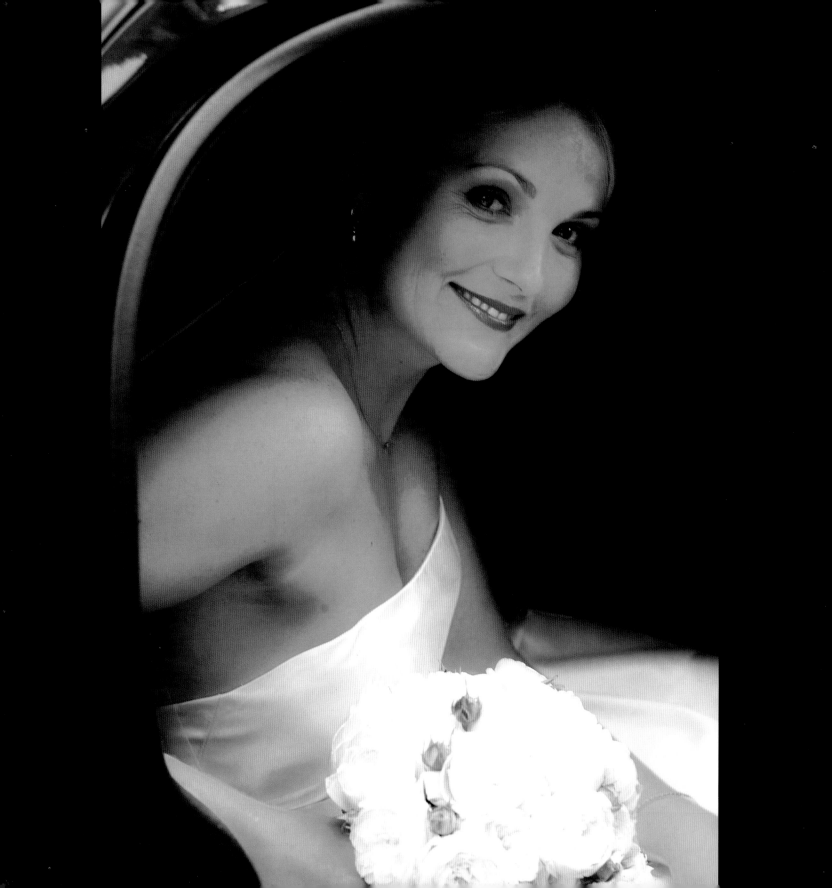

CONTENTS

INTRODUCTION

Digital photography provides many benefits when shooting a wedding. You know immediately what you've shot and that your equipment is functioning the way you want it to. You use less equipment, since there's no need for bags of film, heavy strobes, heavy camera equipment, or even light meters. You only print the images you really like, so editing is quicker. Tasks that once required hours of darkroom work can now be completed in front of a computer in a matter of minutes. Your creativity in producing the final image is limited only by the special-effects tools to which you have access when editing, and retouching is easy—just a matter of using software.

For all these benefits, though, digital photography provides no magic wand for creating a beautiful image. You still have to understand the basic rules of photography to create good images! If you don't understand the basic principles of photography before you start shooting digital you're in for a rude awakening. As with film, the challenge of digital photography is discipline. If you are sloppy in creating images on film and leave exposure problems to your lab to fix, don't expect digital to be the panacea for all that ails you.

Once you master those basics, though, digital gives you the ability to enhance your creativity, perhaps in more ways than you ever thought were possible. The truth is, digital technology puts more tools at our disposal than we have had at any other time in the history of photography.

In the pages that follow we're going to explore the elements that make the digital medium so different from film and those that make it the same. We're going to talk about creating the images, getting them out of the camera, enhancing them with filters and other software, working with the lab, and, finally, selling them. We do our best to cover the art of digital wedding photography from soup to nuts and to address the issues that confront any wedding photographer who makes the switch from film to digital. You'll need to stay on top of digital media, though: In just the time it will take you to read this book, something in photography will have changed. This truth leaves us with one basic assumption that the best photographers in the world have always known: You can never stop learning, because the best image you'll ever take hasn't been taken yet!

Digital technology puts more tools at our disposal than we have had at any other time in the history of photography.

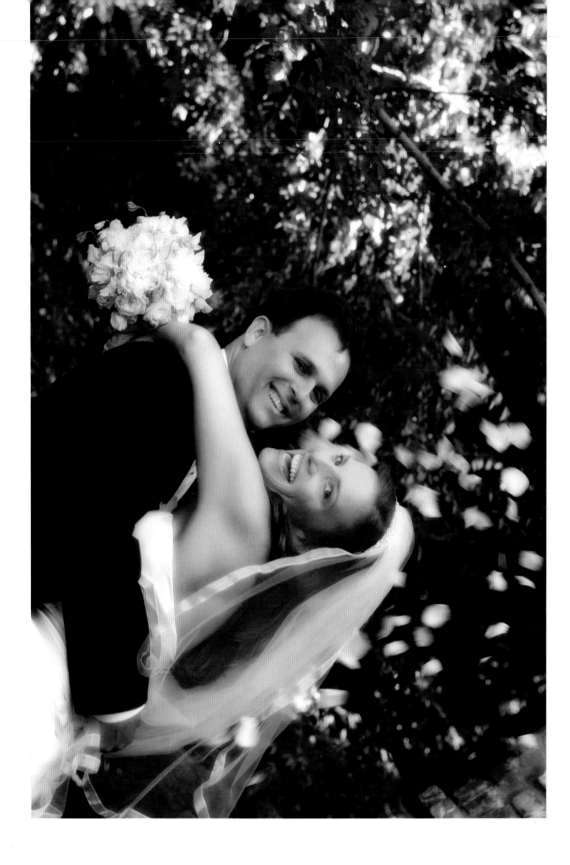

Once you master digital technology, you'll have almost as much fun at a wedding as your clients do.

70–200M LENS SHOT AT 70MM, 1/80 @ f5.6; EXP AV; PHOTOSHOP BLACK AND WHITE CONVERSION

DIGITAL BASICS

To photograph digitally, you need to grasp a few basics. Here are eight controls and features

you'll want to master early on in your digital image-making. Take the time to become comfortable using them, and you'll soon be able to create the best possible images with consistency.

Exposure

Unlike film, digital imaging doesn't allow you to compensate for underexposure or overexposure in the processing stage. Too much light, overexposure, will result in pale, washed-out images; too little light, underexposure, will result in dark, muddy images. Your digital camera's light meter will help you automatically achieve the right exposure. Plus, when you shoot in Raw mode, the exposure compensation feature allows you to override automatic settings and counteract lighting conditions that the light meter might otherwise not adjust for—you usually have a four-stop range in exposure compensation, two stops over and two under.

85MM LENS, 1/1000 @ f2.8, ISO 200;
EXP: AV; PHOTOSHOP BLACK AND
WHITE CONVERSION

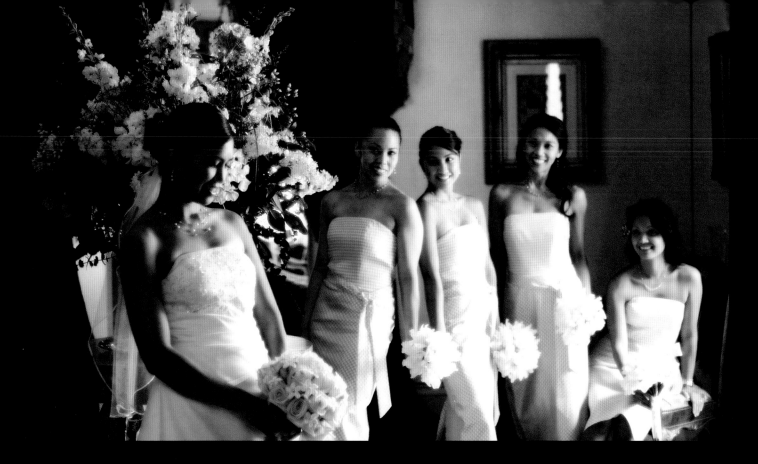

28–70MM LENS SHOT AT 48MM, 1/60 @ f2.8, ISO 400; EXP: AV; PHOTOSHOP BLACK AND WHITE CONVERSION

Aperture

By setting your camera to aperture priority mode, you can choose the aperture, or f-stop (in automatic and other modes, the camera will determine the aperture setting). Our preference is to use a large aperture to achieve a nice, shallow depth of field, which helps blur out distracting backgrounds. Typically we shoot at f1.2 to f2.8.

Buffer memory and card writing speed

These terms refer to how many images you can shoot consecutively. With cameras like the Canon EOS-1D Mark II you can shoot up to 20 Raw files in a row at speeds up to 8.5 frames per second. That's a lot of data! With a fast card-writing speed like 5 megabytes per second or higher, you're not going to wait as long for your camera to clear its buffer memory as you would with a system that only writes at 2 megabytes per second or slower. You don't want to miss the best moments of the wedding because you are waiting for your camera to finish writing to the card.

Focusing speed

It's imperative to have a camera that's fast to focus in the autofocus mode. You don't have time to wait

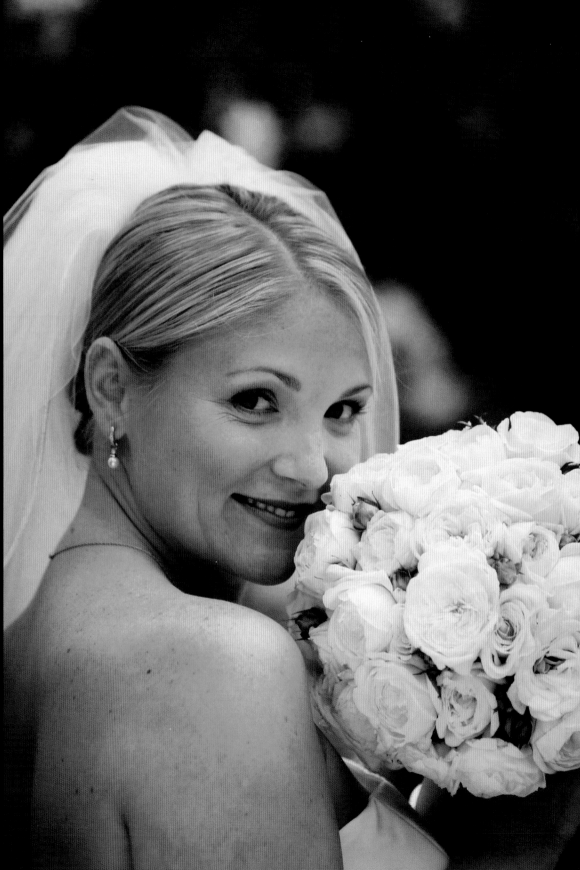

BELOW: **85MM LENS, 1/30 @ f2.0, ISO 400; EXP: AV**

RIGHT: **70–200MM LENS SHOT AT 185MM, 1/1600 @ f3.2, ISO 200; EXP: AV**

Resolution

Shoot everything at the very highest resolution your camera will allow—that is, with the most pixels, so the image is as detailed as possible. This way, you'll have more flexibility when it comes to cropping an image and more options when printing.

Downloading programs

You want easy-to-use programs for downloading and managing your files. Phase One's Capture One makes it easy to rename and batch files and to do color correction and make other adjustments (see page 114).

The LED viewfinder

This feature is an asset when experimenting with a new technique, since it allows you to get an idea of how the image will turn out before you snap the shutter. However, don't get into a habit of viewing every image in the LED display, because you don't have time and you should learn to follow your instincts. And never get into the habit of "chimping"—making a sound like a chimp when you see the image you just captured in the viewfinder, as in "ooooh, ooooh, ooooh!"

Diopter adjustment

This is really basic, but there will be moments when you may need to focus manually. Make sure you know where the diopter adjustment, which lets you manually focus on objects, is located on your camera and periodically check to see that the viewfinder is set for your eyes.

70–200MM LENS SHOT AT 150MM, 1/320 @ f5.0, ISO 200, EXP: AV

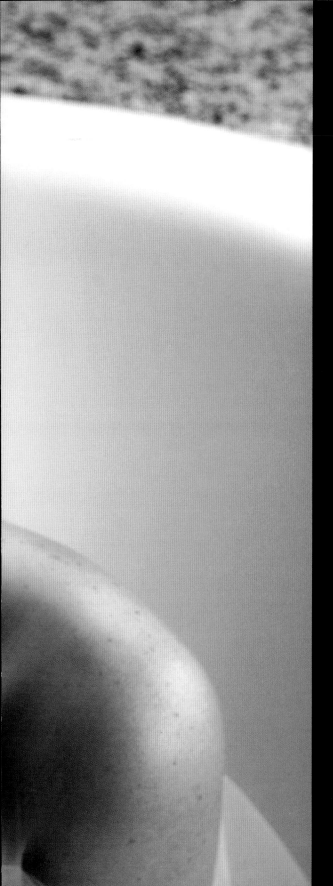

BEFORE THE EVENT

GETTING TO KNOW YOUR CLIENT

GEARING UP

TIPS AND TECHNIQUES

A truly great photographer knows that the one key ingredient in an outstanding image has nothing to do with equipment or even creativity. A photographer must see and capture the intangible. It's about freezing the excitement of the moment and the enthusiasm of the subject—in short, the emotion.

GETTING TO KNOW YOUR CLIENT

As a wedding photographer, the key to your success is the respect you have for your client.

Your clients hire you to be their eyes on one of the most important days of their lives.

More than that, your success depends on your ability to become your client. Your clients don't hire you just to make an album. They hire you to be their eyes on one of the most important days of their lives and to see the world the way they do.

You'll develop the ability to know your client in the work you do before the wedding. We spend our careers as photographers learning about technique and too often wind up with a preconceived notion of how to get a shot. In wedding photography, it's all about understanding how your clients perceive themselves. You have to spend time with your clients and learn to read between the lines. Listen, observe, ask questions, and communicate. Here's where you make the switch from professional photographer to psychologist, determined to understand the human spirit. In order to succeed you have to learn everything you can about your clients in just a few short meetings and phone conversations. Do it right and on that big day you'll be able to walk in and see the world through their eyes.

Don't be afraid to bend the rules in order to capture the bride's and groom's distinctive personalities. With a little experimentation you'll create memorable images.

RIGHT: 28–70MM LENS SHOT AT 70MM, 1/15 @ f5.6, ISO 200; EXP: AV; NIK MULTIMEDIA FILTER: COLOR INFRARED

OPPOSITE: 28–70MM LENS SHOT AT 28MM, 1/250 @ f3.5, ISO 200; EXP: AV; NIK MULTIMEDIA FILTER: MONDAY MORNING

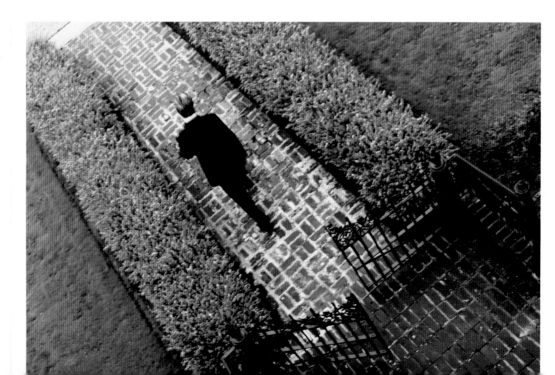

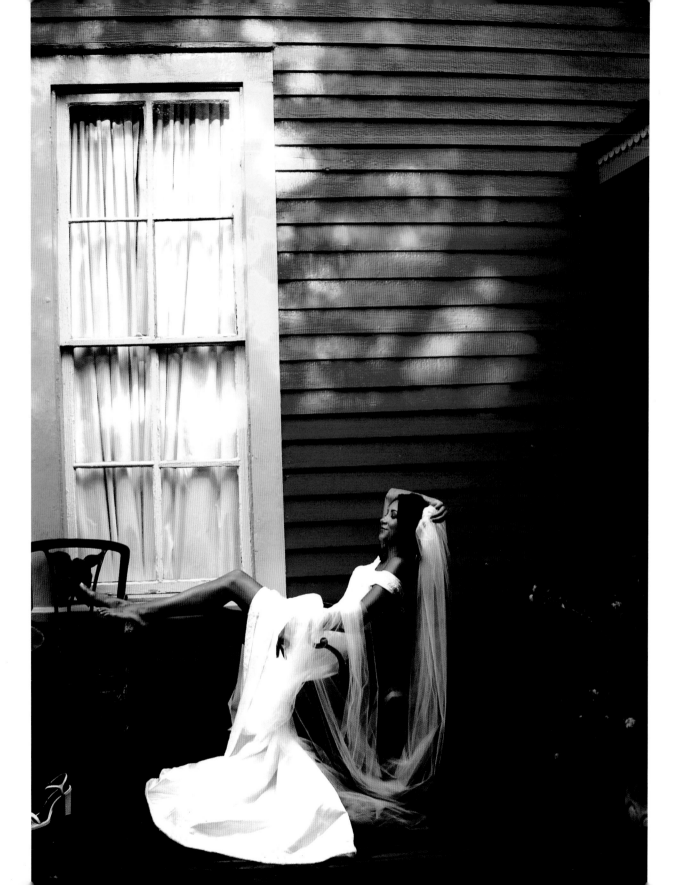

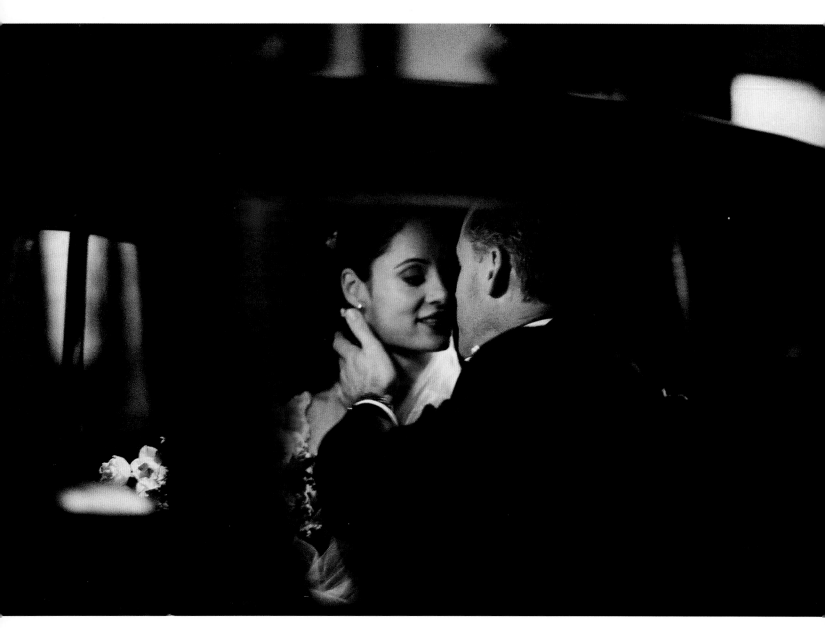

A good wedding photographer captures the emotion of the day without being intrusive. In order to anticipate these moments, you need to know your clients well so, in turn, you know what to look for.

85MM LENS, 1/15 @ f1.8, ISO 800

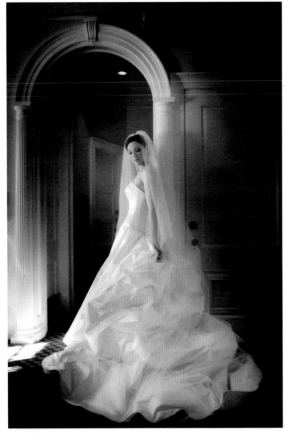

It's all about
understanding
how your clients
perceive
themselves.

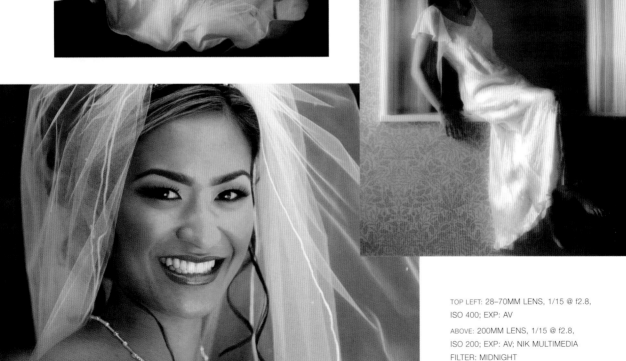

TOP LEFT: 28–70MM LENS, 1/15 @ f2.8,
ISO 400; EXP: AV

ABOVE: 200MM LENS, 1/15 @ f2.8,
ISO 200; EXP: AV; NIK MULTIMEDIA
FILTER: MIDNIGHT

LEFT: 200MM LENS, 1/60 @ f2.8,
ISO 100; EXP: AV

As you get to know your clients, you'll get a sense of who they are. You'll also come to realize the types of images that will capture them and excite them. In these pre-wedding informals, the creative approach, techniques, angles, setting, and clothing say legions about the subjects. They capture mood, taste, lifestyle, and, most important, the way couples relate to one another.

28–70MM LENS SHOT AT 47MM, 1/400 @ f3.2, ISO 200; EXP: AV; NIK MULTIMEDIA FILTER: MONDAY MORNING

28–70MM LENS SHOT AT 48MM, 1/500 @ f3.2, ISO 200; EXP: AV; NIK MULTIMEDIA FILTER: DUPLEX

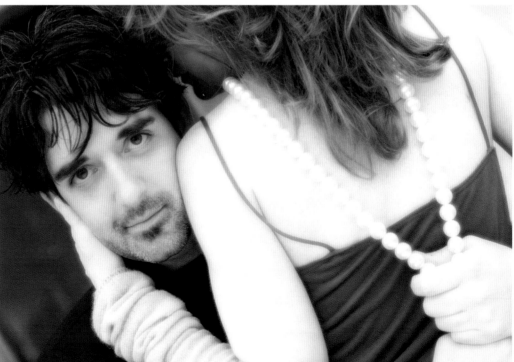

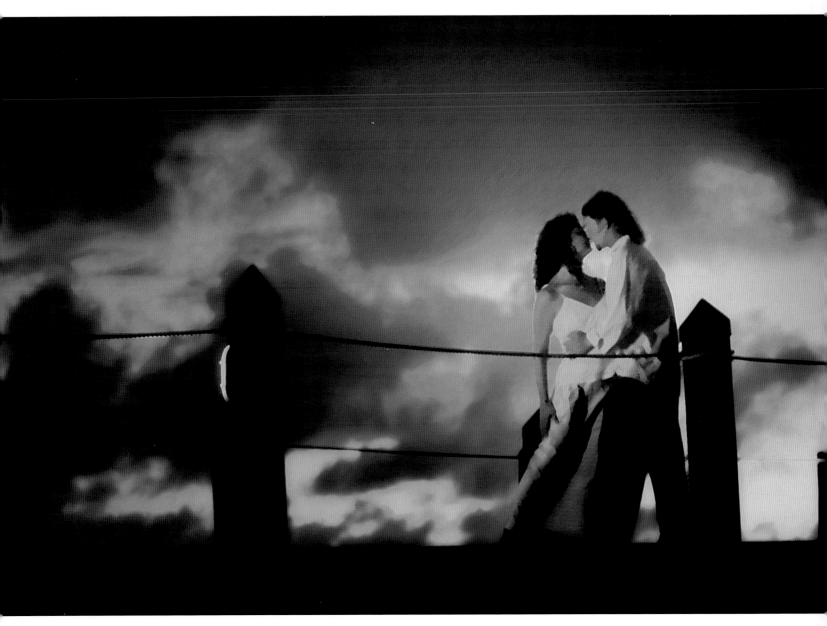

All sorts of distinctive locations are appropriate for pre-wedding shots. Since these photos are usually informal and often include an atmospheric setting, you have a wonderful chance to capture the personality of the couple.

70–200MM LENS SHOT AT 80MM, 1/20 @ f2.8, ISO 640; EXP: AV; NIK MULTIMEDIA FILTER: MIDNIGHT VIOLET

TWO WEDDINGS,
TWO PERSONALITIES

Let's look at examples of two totally different clients. Bride A comes in to meet with you.

She stepped right out of a Nordstrom's catalog. Everything about her is color coordinated. Her handbag matches her shoes. Her nails are perfectly manicured, her hair and makeup are just right. What does that tell you about the client?

Right off the bat you know she's into detail. She understands fine fabrics. She has an eye for quality. Whether she has money or not is irrelevant. She has very specific tastes.

28–70MM LENS SHOT AT 28MM,
1/40 @ f6.3, ISO 400: EXP: M:
QUANTUM QFLASH (f7.0) AND VIVITAR
285 FLASH SLAVE

Now let's move on to Bride B. She walks into your studio twenty minutes late for her appointment and is wearing jeans with a few holes in them. She bites her nails. Her hair is pulled back in a ponytail and her makeup is pretty basic. She's wearing a Cornell University sweatshirt.

Bride A is a piece of cake to figure out. Her wedding is going to be organized. She's going to leave no room for inadequate planning. She's going to be efficient and detail oriented throughout the planning process and at the event itself. She's a bridal machine and you've got to understand exactly what she wants if you're going to get into her mind-set.

She knows what kind of photos she wants. Most likely, these will be a balance of formal images and those that provide exquisite storytelling. She's a traditionalist and she probably won't want an overly contemporary album design. She's also going to be directive and want some very specific shots. The approach to her photography is likely to be formal and traditional.

Bride B is a bigger challenge and for many of us she is the typical client. We can't draw any preconceived notions about her. We have to draw her out to understand who she is. We'll start with a simple question like, "Who designed the gown you'll be wearing?" Getting that answer is your first key in understanding what your client wants. If she doesn't know, then ask her to describe the dress.

If she's wearing a big puffy ball gown, she'll probably want an approach that stresses romance and a traditional look. If she's wearing a tight, slinky, contemporary slip-look dress, she's probably into high fashion. The photography for her wedding will probably be more sophisticated. We might exaggerate her posing a little more. We might shoot with a more illustrative style.

Obviously we're taking the liberty of drawing some broad generalities. But we can do that to make our point: Get to know your client!

85MM LENS, 1/60 @ f2.0, ISO 200; EXP: AV: PHOTOSHOP BLACK AND WHITE CONVERSION, PAINTED BACK IN THE SELECTED AREA IN COLOR

GEARING UP

Working with digital, you need to master some technical disciplines before you shoot

a wedding—or, for that matter, before you take your very first shot. The first step is to become familiar with the gear and to develop a sense of what equipment you need to have on hand so you can comfortably capture all the aspects of a wedding. Digital photography also requires organization and a good work flow. That is, you need to become familiar with the best ways to capture, download, store, and view images.

In the next pages, we discuss some of the techniques we've developed since we put our film cameras away and made the move to digital. The first question many photographers ask us is what kind of camera to use. That's a big issue, since the market is flooded with options when it comes to choosing professional digital cameras and gear. Bambi's digital camera manufacturer of choice is Canon, and Canon is always introducing new equipment for the professional. Canon camera bodies have traditionally had the fastest capture rate (frames per second) in the digital market. The lenses are incredibly sharp and faster to focus, and Canon equipment is unfailingly reliable.

The market is flooded with options when it comes to choosing professional digital cameras and gear.

RIGHT: 70–200MM LENS SHOT AT 200MM, 1/400 @ f5.6, ISO 200; EXP: AV

OPPOSITE: 28–70MM LENS SHOT AT 28MM, 1/30 @ f2.8, ISO 400, EXP: AV

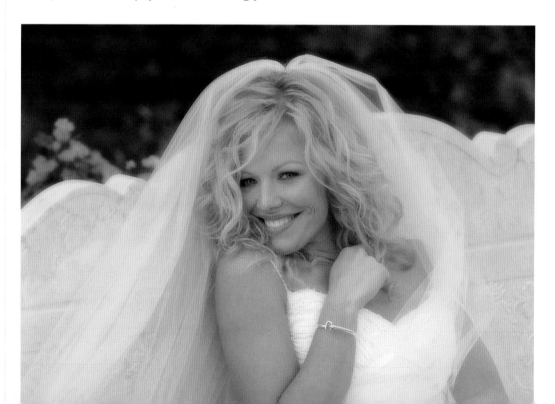

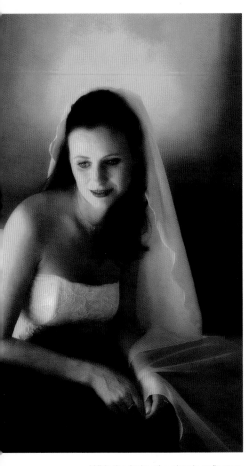

ABOVE: With the help of a simple reflector, you can wrap light around your subject and create a wonderful play of shadow and light. The reflector was camera right.
85MM LENS, 1/60 @ f2.0, ISO 200; EXP: AV

RIGHT: A filter creates the mood, but the impact comes from the pose and components surrounding the bride.
85MM LENS, 1/250 @ f2.3, ISO 200; EXP: AV; NIK MULTIMEDIA FILTER: MIDNIGHT SEPIA

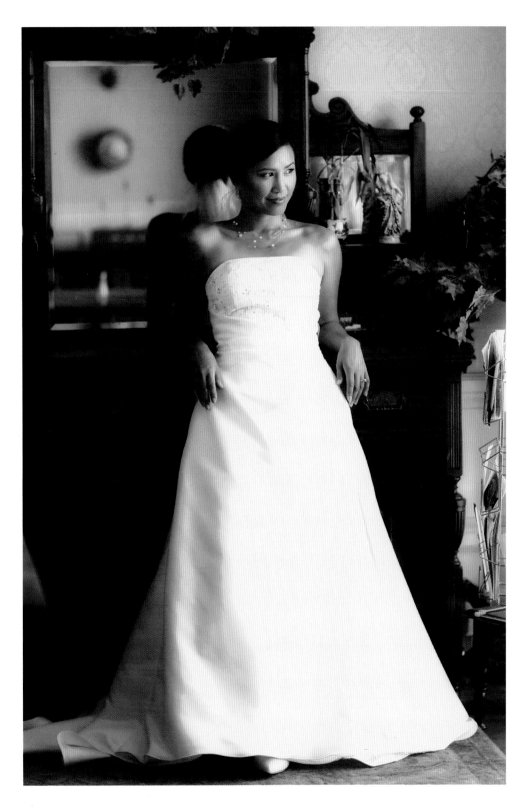

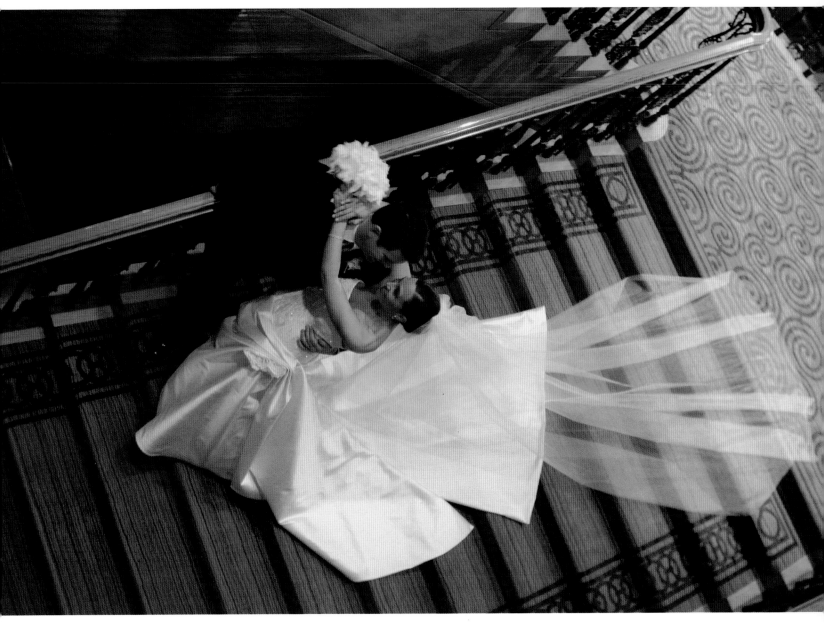

Shooting the bride and groom from above is a favorite approach, especially when you can utilize the stairs and the environment to show the full train of the gown.

28–70MM LENS SHOT AT 35MM, 1/15 @ f2.8, ISO 1600; EXP: AV; NIK MULTIMEDIA FILTER: MIDNIGHT

Bambi's Equipment Check-off List

A day or two before the event, lay out all of your equipment and do an inventory check. No piece of equipment is too small or insignificant that it shouldn't be included in this exercise. Of course, you'll also have a few of your own favorite items that you want to bring along. We're not necessarily talking about sophisticated equipment. How about a small note pad, in case you want to jot down some notes about locations or subjects? An energy bar, in case no one remembers to arrange to have a plate of food for you at the reception? You get the point: If there's an item that you always like to bring along to shoots, lay it out with the rest of your equipment so you don't leave it behind.

- 2 Canon 1D Bodies. Only an amateur goes off to an event with just one camera. You need at least two camera bodies and ideally, three. The first body is going to be your primary camera and the second is a backup. You should set up the third with a different lens so you don't miss a shot because you were busy changing to a lens with a different focal length!
- 1 Canon Mark II body
- Canon 70-200mm 2.8 IS L
- Canon 28-70mm 2.8 L
- Canon 85mm 1.2 L
- Canon 14mm fisheye
- 2 Metz 45CT-4 flashes
- Radio slaves: 1 pocket wizard transmitter and 2 receivers
- Gitzo Tripod. Have a decent tripod with you; you'll probably need it for formals and other group shots. Also have one monopod on hand that you can use for a secondary lighting setup with one of your portable strobes.
- EXPODisc to set white balance
- 2 Canon 550 EX strobes
- Forty 256mb CompactFlash memory cards (620mb cards are also used), on which you'll be storing your images. We recommend using 256mb cards rather than larger capacity media—this way, if something happens to one card, you won't lose the entire event. You'll get about 40 images on a 256mb card when shooting in Raw format.
- 2 Tamrac media card holders, each holding at least 20 cards each. You want a soft-sided case, with easy access and a design allowing you to hang it off the side of your camera strap.
- 3-4 blank DVDs. Always have a supply of blank DVDs at hand. Don't forget a couple of black Sharpie markers—you can't write on a DVD without one.
- Laptop computer. Don't go to any wedding without your computer and associated peripherals.
- Porter Case. Porter Cases are ideal. They're light, durable, and best of all, they save your back. They fold out and turn into a cart, making it easy to transport your gear.

A day or two before the event, lay out all of your equipment.

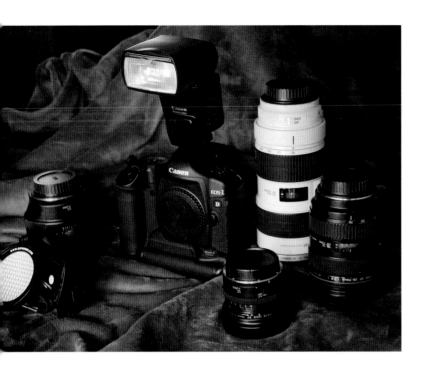

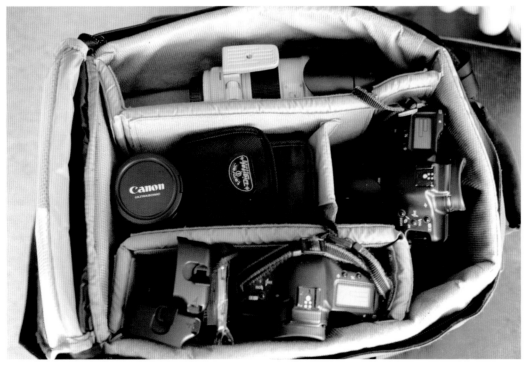

Geared up for the wedding, clockwise, from top left: Canon EOS 1D MarkII, with Canon 580EX strobe, 14mm fisheye lens, 70–200mm lens, and 28–70mm lens; a Tamrac media card holder; and the case, packed and ready to go.

A PRE-WEDDING TECH CHECK

The frantic moments just before the ceremony are no time to test equipment and techniques

or to organize gear. Here's a run-through that we suggest you do before you leave the studio for the wedding.

Get EXPODisc to set the white balance

White balance is a digital tool that ensures colors will be rendered naturally under various lighting conditions. In a ballroom, for example, the light may have a golden tone, while outdoors in the evening the light will have a bluish cast. White balance neutralizes these lighting conditions to provide a neutral color rendition in all of the images you capture in a specific lighting situation.

While digital cameras have automatic white balance settings, you will want to set the white balance controls yourself for the best color control. We use a filter called EXPODisc. When you hold the disk in front of the lens as you point the camera at a subject, you see a "gray frame" that allows you to set a custom white balance that results in accurate color. Whenever you change locations it's a necessity to establish the white balance for that scene.

Check the chip

Well before every event you need to check for dust on the chip in the camera. Put on any lens, point the camera at a light source, and shoot with the lens open wide. Any dust on the chip will show up immediately. A squeeze-ball blower will usually get the dust off, but if dust remains, you'll need to send the camera in for service and cleaning. So, allow enough time for any necessary repairs.

Use separate cards and card holders for each camera

Keeping the cards separate will help you stay organized and cut down on the general confusion that can ensue during a busy wedding. Don't waste your money on holders that store only two to four cards. You want the ones that store at least twenty cards. Make sure the case is designed to hold the cards securely and that they won't fall out during the chaos of shooting the wedding. As a test, load up the

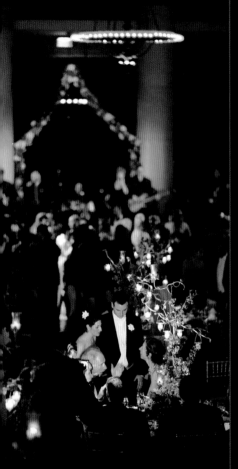

The videographer's light was the primary light source for a shot that, taken from a good vantage point, suggests the romance of the setting.
85MM LENS, 1/50 @ f1.2, ISO 400; EXP: AV

Stock up on CompactFlash cards

Make it a practice never to reuse a card during the same event. You know whether or not a roll of film has been exposed, but that's not the case with a CompactFlash card. You don't know if it's full or even if it's been used, and you run the risk of overwriting your images. So, before using your cards, number or letter them consecutively. Put them in the card holder in sequential order and remember to use them only in this order. This way, you'll know exactly what you've used.

Bring your laptop

You should always have your laptop with you so you can download images on the spot and view them at intervals during the wedding. This way, you can make sure there are no surprises in store for you—that you won't get back to the studio and discover something has gone wrong. In fact, your assistant can back up your data and burn DVDs during the reception. We prefer to use a laptop, but many photographers use portable card readers. With these devices, you simply insert a CompactFlash card and download the images for storage. Some download devices have built-in viewers.

Keep your lighting equipment simple and portable

Flashes as simple as the Vivitar 285, the Metz 45CT4, and the Quantum Qflash are going to give you what you need for most of your needs. You should always have a couple of radio slaves for additional lighting to add to your creativity. One Pocket Wizard transmitter and two receivers will do the trick. You're going to be using these primarily on your indoor formal photographs and reception lighting at night. We recently tested the Canon Mark II camera together with Canon's 550 EX Flash. The results were extraordinary. They're lightweight and couldn't be more portable. In addition, the radio slave is already built-in!

Bring a variety of lenses

Ideally, you should bring a 70–200mm 2.8 IS L, 28–70mm 2.8 IS L, 85 1.2 L, and a 14mm fisheye. The "IS" stands for Image Stabilizer, a type of lens that allows you to capture images at slower shutter speeds, allowing you more leeway with lighting conditions. IS lenses allow a steady-handed photographer to comfortably hold the camera and shoot down to 1/4 of a second without the appearance of camera movement. These lenses cost more, but they're well worth the investment.

To inject drama to the moment when the bride begins her walk down the aisle we metered on the brightest spot in the scene, her dress, to create a silhouette effect.
28–70MM LENS SHOT AT 28MM, 1/60 @ f2.8, ISO 320; EXP: AV

TIPS AND TECHNIQUES

Okay, you have the gear. Now let's see how to make the best use of it. Unfortunately, too many photographers think that just because they bought great equipment, they're ready to create great images. Digital imaging gives you the ability to easily defy all the rules of photography, but you have to know the rules before you can break them. Every photographer who buys a digital camera should first be forced to master shooting transparency film. (Actually, the properties for that chip in your digital camera are very similar to the properties of a roll of Kodak Ektachrome!) Whether you're working with film or the latest digital technology, if you don't understand the basics of depth of field, exposure, lighting, composition, and other basics of photography, your images won't necessarily be any better than those Uncle Harry takes with his $99 point and shoot!

> Too many photographers think that just because they bought great equipment, they're ready to create great images.

A unique angle, with the aid of a black-and-white conversion, captures a private side of a bride. 85MM LENS, 1/160 @ f5.6, ISO 200; EXP: AV; CONVERSION TO BLACK AND WHITE

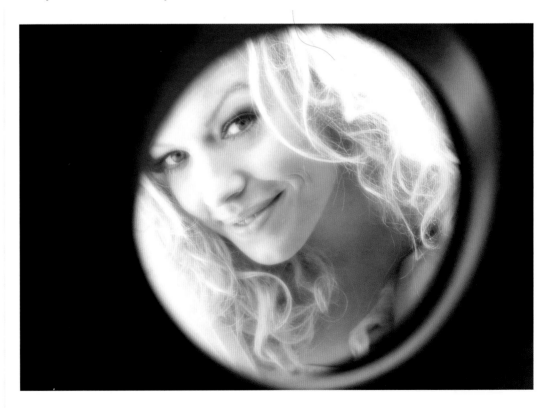

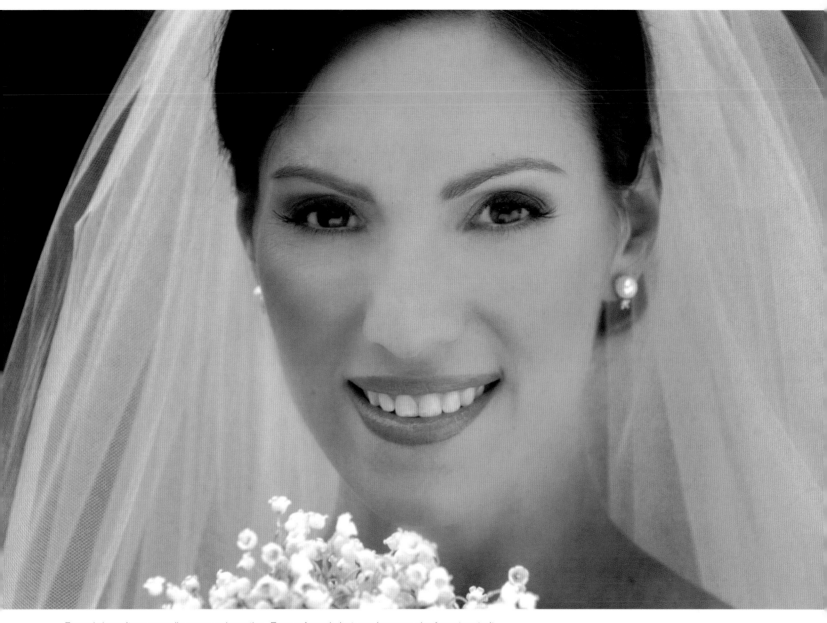

Formal doesn't necessarily mean uninventive. Even a formal shot can have an air of mystery to it.

70–200MM LENS SHOT AT 148MM, 1/25 @ f2.8, ISO 200; EXP: AV; NIK MULTIMEDIA FILTER: INFRARED

LENSES

You need to understand how each lens performs in order to maximize creativity. With every image or series of images there are several basic questions you need to ask yourself:

- What's the subject?
- How soft do I want the background to go?
- How much room do I have?
- How much time do I have to get the shot?
- How much existing light is in the room?

Over time, asking yourself these questions becomes as instinctual as the thought process it takes to lift your foot when going up a flight of stairs. You'll find you can look at a situation and almost instantly know which lens will give you the most flexibility. Learn to anticipate your needs. As a good photojournalist, you have to be able to determine what's needed before you start to shoot. Prepare for the unexpected, and remember Murphy's Law—If anything can go wrong it will. Then remember that Murphy was an optimist!

As the day progresses and scenes change, so do the opportunities to use different lenses. Remember, there are two reasons to switch lenses. First, you make a switch because different lenses give you more to work with and help you answer those five questions we started with. Second, and this is even more important, every wedding is unique. You've got to make your work look different every time and give the bride and groom what they deserve: a unique album that captures the emotion and tells the story of the day in a way no one else could!

> You'll find you can look at a situation and almost instantly know which lens will give you the most flexibility.

Longer lenses allow you to step away from the action. This way, you can unobtrusively capture images that naturally tell the story. The 70–200mm f2.8 IS lens is especially useful: It provides image stabilization (IS) with a great choice of focal length. You can be farther away from the action and, with the IS feature, work with slower shutter speeds without having to worry about camera movement.

70–200MM LENS SHOT AT 200MM, 1/50 @ f2.8, ISO 1600; EXP: AV

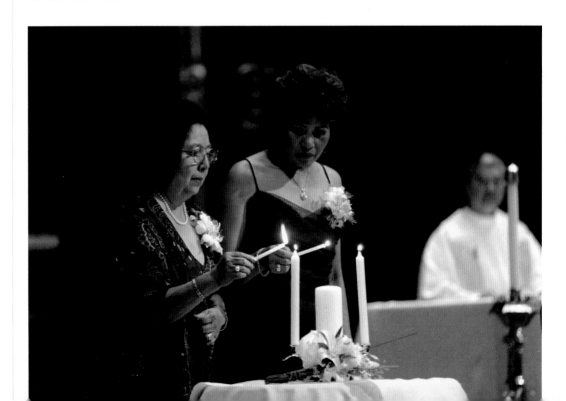

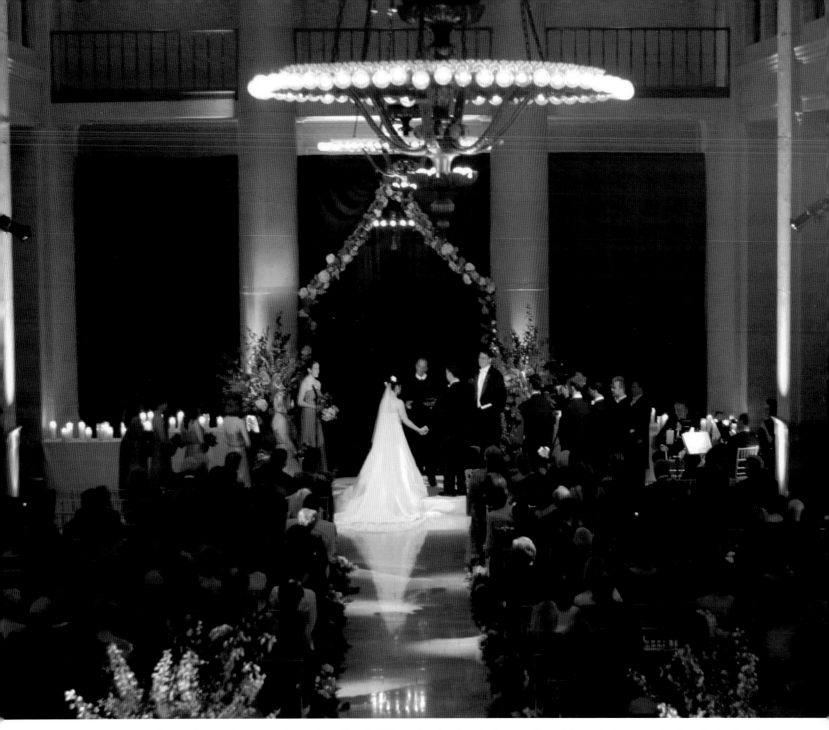

You can't photograph a wedding without a good zoom lens. The 70–200 mm lens is a favorite for versatility and for capturing moments when the best seat in the house might be in the back of the room!

70–200MM LENS SHOT AT 110MM; 1/50 @ f2.8, ISO 1600; EXP: AV; NIK MULTIMEDIA FILTER: DUPLEX

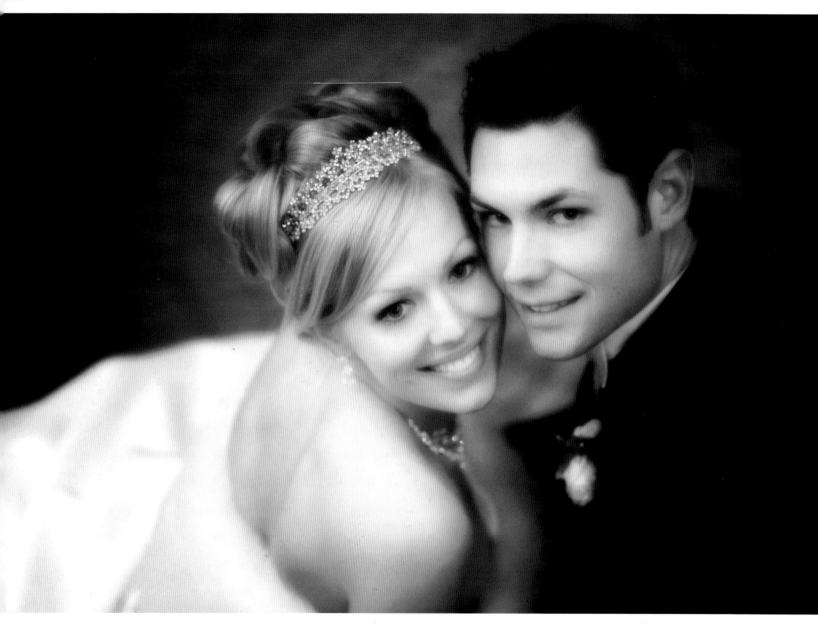

You can capture images in low light—without the intrusion of a flash—with a combination of the right lens, a wide aperture, and a high ISO. Notice the completely compressed depth of field.

85MM LENS, 1/30 @ f1.2, ISO 1600; EXP: AV; NIK MULTIMEDIA FILTER: INFRARED: BLACK AND WHITE

Most photographers use a wide-angle lens automatically when shooting groups, but don't be afraid to mix it up a little.

ABOVE: 28–70MM LENS SHOT AT 70MM, 1/160 @ f6.3, ISO 200; EXP: AV

LEFT: 28–70MM LENS SHOT AT 55MM, 1/50 @ f4.0, ISO 200; EXP: AV

Using Zone Focus

The trick for getting great shots on the dance floor, assuming you have the right lens and exposure, is to turn off the auto-focus and go into what is known as zone focus. Pre-focus your lens to six to seven feet and set your aperture and flash to f5.6; typically, your shutter speed will be at 1/30th of a second for a dark ballroom. Every image is going to be in focus as long as you stay within that six-foot range. You're going to be shooting fast, with no delay waiting for the autofocus feature to do its job. You'll be able to move in and out of the crowd, spending your time anticipating the decisive moment, instead of thinking about your camera gear. It's important, too, to set your camera in the manual-metering mode.

A change to the 28–70mm lens gives you a wider angle and is ideal for reception photography.
28–70MM LENS SHOT AT 55MM, 1/30 @ f5.6, ISO 200; EXP: M

17–35MM LENS SHOT AT 17MM, 1/15 @ f4.5, ISO 800; EXP: M

SLOW SHUTTER SPEEDS

Slow shutter speeds allow you to add motion to your images. This is especially effective on the dance floor and in other locations where you want to add a sense of movement. Motion, romance, fantasy—they bubble right to the surface when you drag the shutter.

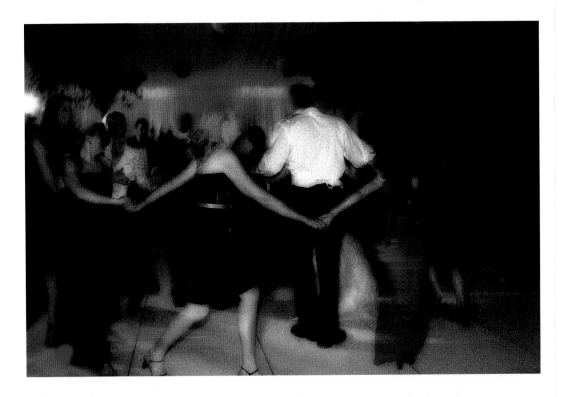

To add motion to an image, start with a slow shutter speed. This image was further enhanced with a nik multimedia Monday Morning Filter (see page 130).

28–70MM LENS SHOT AT 28MM, 1/4 @ f5.6, ISO 400; EXP: M

A dance floor scene becomes an Impressionist image with a super-slow shutter. While you don't want to overdo these arty shots, a few are nice additions to an album.

28–70MM LENS SHOT AT 28MM, 3 SEC @ f2.8, ISO 400; EXP: M

A slow shutter imparts a sense of mystery to this behind-the-scenes image. Is the bride rushing downstairs to the ceremony? Is she about to join the reception?

14MM FISHEYE LENS, 1/10 @ f4.0, ISO 200; EXP: AV; NIK MULTIMEDIA FILTER: DUPLEX

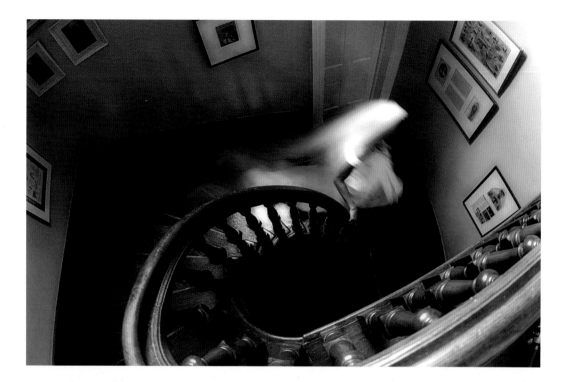

A double-angled approach: With cameras at the front and back of the church, you will be assured of getting the most dramatic impact out of the ceremony.

28–70MM LENS SHOT AT 28MM, 1/4 @ f3.5, ISO 400; EXP: AV

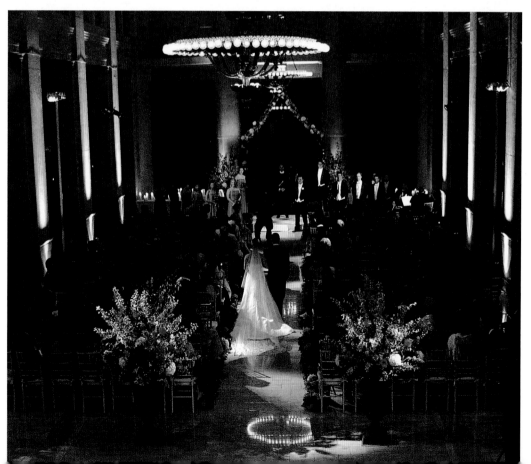

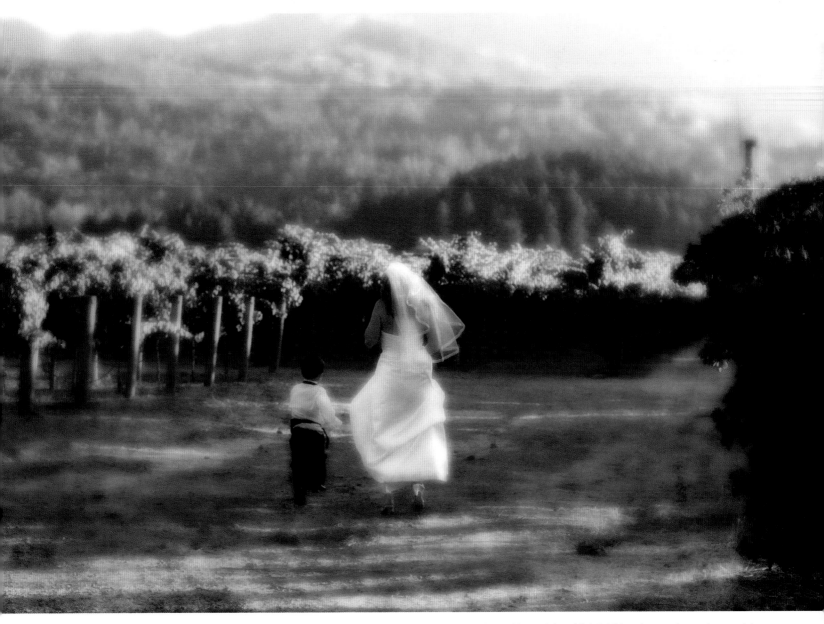

Pay attention to your surroundings. Some of your most creative images will come from capturing subjects doing delightful things in amazing environments!

70–200MM LENS SHOT AT 150MM, 1/25 @ f2.8; EXP: AV; PROOFZ INFRARED 1

Shallow depth of field, in which the subject is in sharp focus and the background is blurred, can be especially effective. Stand close to the subject and open up the aperture to f/2.4 or f/4 or so. Using a shallow depth of field, you can bail yourself out of tough shooting locations in which you have a wonderful subject but an unattractive or distracting background. By focusing so closely on your subject, you will capture expressions that can add emotion to your images.

DEPTH OF FIELD

Depth of field, the zone of sharpness between the nearest and farthest parts of your scene, is a great tool. Depth of field is determined by the distance you stand from your subject, as well as by the lens settings and focal lengths you use. The lower the f-stop (that is, the larger the aperture), the shallower the depth of field.

By working with a shallow depth of field, you can isolate your subject.
85MM LENS, 1/80 @ f2.0, ISO 200; EXP: AV

A narrow depth of field is the ideal tool to help you isolate special details of the wedding day.

TOP LEFT: 85MM LENS, 1/40 @ f1.4, ISO 800, EXP: AV; NIK MULTIMEDIA MIDNIGHT FILTER

ABOVE: 85MM LENS, 1/15@ f1.2, ISO 800, EXP: AV, NIK MULTIMEDIA MONDAY MORNING FILTER

LEFT: 85MM LENS, 1/60 @ f1.2, ISO 200; EXP: AV

CAMERA TILT

Simply by tilting the camera you can add interest to your images. Camera tilt can depict motion and excitement, and it lends an element of illustration to an album. However, using camera tilt is like cooking with garlic: Don't overdo it.

Camera tilt can add a sense of motion, a perfect way to suggest that a bride and her groom are being whisked away after the ceremony.

RIGHT: Camera tilt suggests the bride and groom are, if you'll excuse the pun, really falling for each other.
70–200MM LENS SHOT AT 200MM, 1/60 @ f3.2, ISO 200; EXP: AV

BELOW RIGHT: Here, camera tilt mimics the arc of the rear car window and the sign in the background.
28–70MM LENS SHOT AT 34MM, 1/200 @ f5.0, ISO 200; EXP: AV

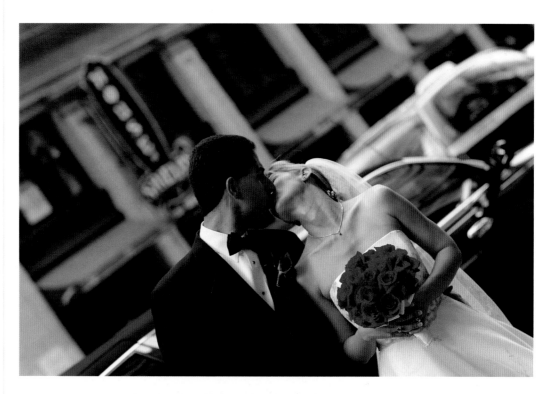

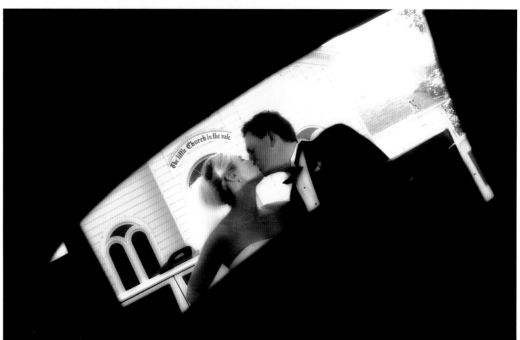

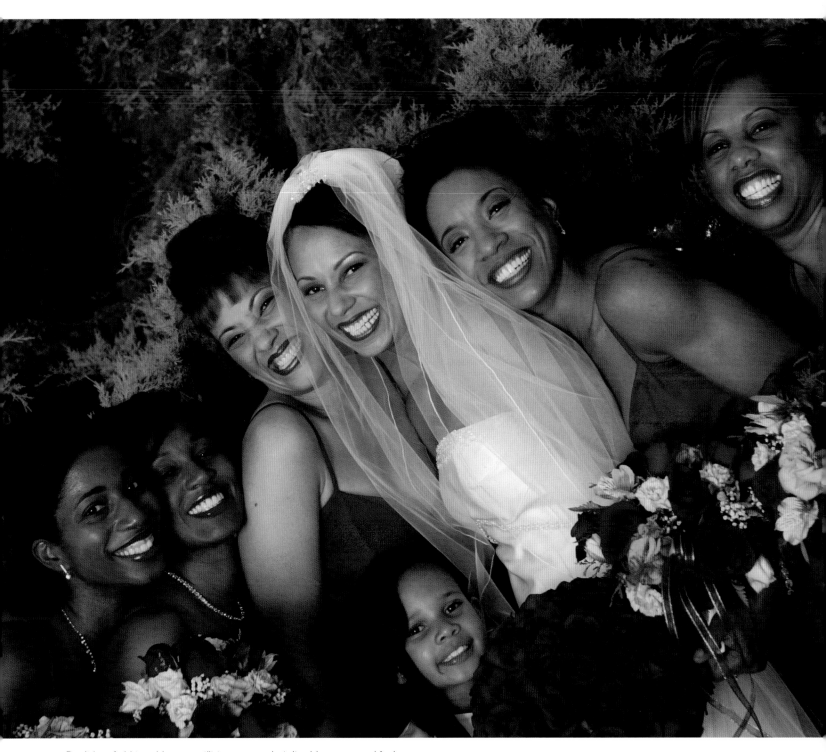

Don't be afraid to add camera tilt to a group shot. It adds energy and fun!

70–200MM LENS SHOT AT 100MM, 1/25 @ f5.6, ISO 200; EXP: AV

LIGHTING

In making the transition to digital, photographers often wrongly assume that the technology reacts to light the same way film does. In reality, digital photography is more sensitive to light, giving you the ability to work more easily in a variety of lighting situations. On the other hand, your flash equipment needs to be more precise when you're using digital equipment. With film, you can overexpose and the lab will fix the image; with digital, if your image is overexposed, that's it—you're done and there's nothing you can do to fix it. Do a test of your lights up front. Decide on the best shutter speed and how much of the background you want to be visible. Choose the aperture you want to work with, determine how much of the scene is in focus, and set your lights accordingly.

OPPOSITE: It's all about simplicity and learning to see the light. Just the light from a spotter in the ceiling brings the bride and groom close together and gives you everything you need for a "wow" print.
85MM LENS, 1/50 @ f1.4, ISO 500; EXP: AV; NIK MULTIMEDIA FILTER: MIDNIGHT SEPIA

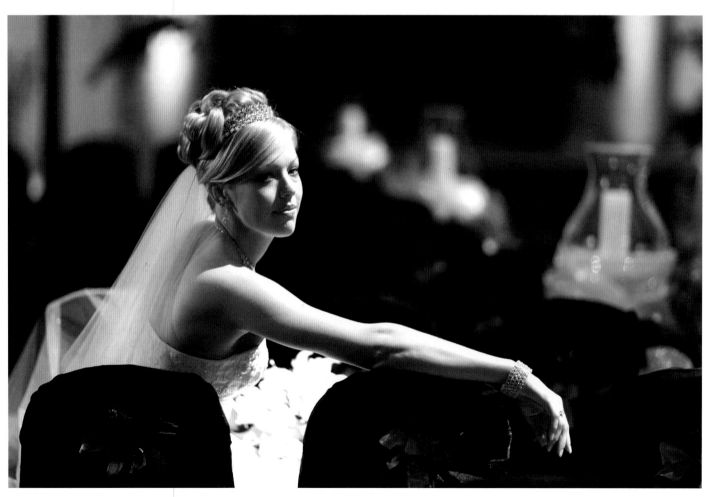

Digital imaging is especially effective when working with available light. Indeed, you can easily capture images that might otherwise have posed a challenge with many of the more commonly used films.
85MM LENS, 1/60 @ f1.4, ISO 500; EXP: AV

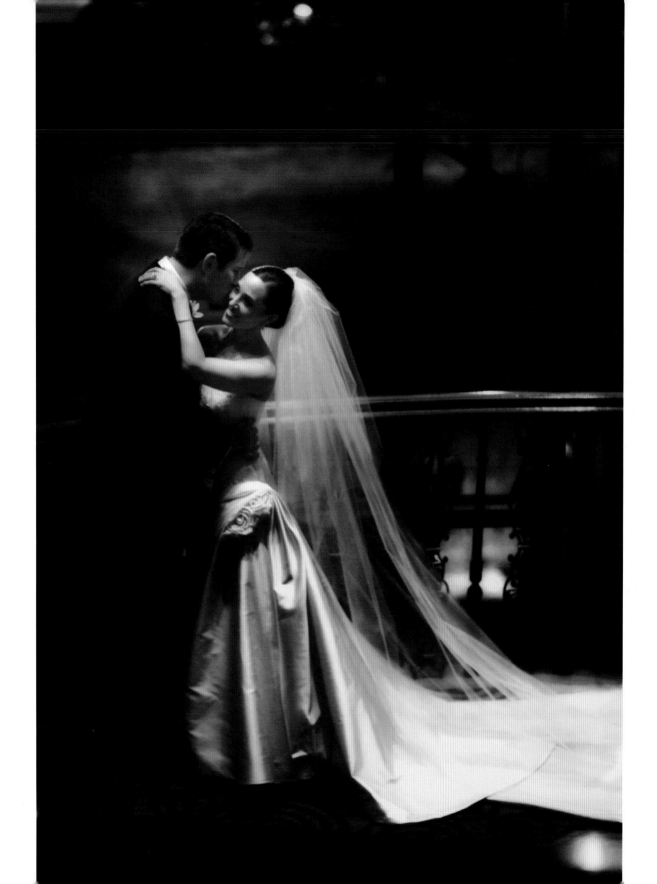

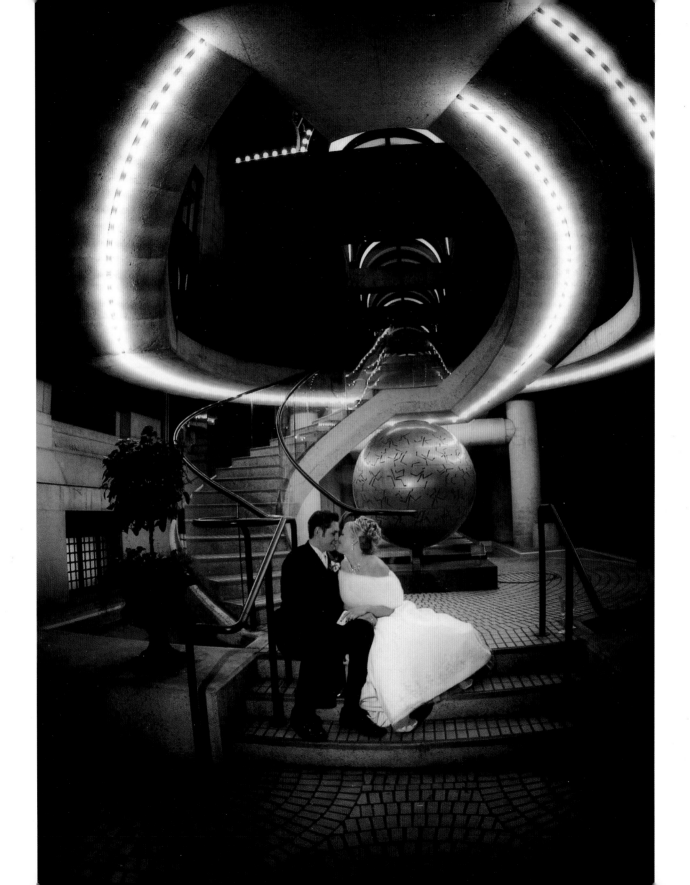

Often, the simplest of settings photographed with available light adds a warm ingredient to the sense of anticipation captured on the face of the bride. Interesting locations are everywhere. We captured this shot in the women's lounge of the hotel—not your typical location for a bridal portrait! 28–70MM LENS SHOT AT 70MM, 1/320 @ f3.5, ISO 1000, EXP: AV; NIK MULTIMEDIA MONDAY MORNING FILTER

RIGHT: Again, it's about lighting and composition. Window light enhances the mood while the canopy of the bed adds a wonderful design element and frames the bride.
85MM LENS, 1/60 @ f2.5, ISO 200; EXP: AV

OPPOSITE: Look for high-impact design elements to include in your images and shoot at a wide angle. Bringing the environment into the image and shooting entirely with available light will help add a dramatic element to the story of the day.
14MM FISHEYE LENS, 1/40 @ f2.8, ISO 800, EXP.AV; NIK MULTIMEDIA FILTER: MONDAY MORNING

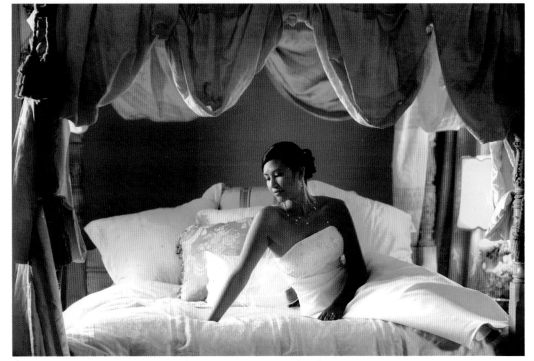

BE PREPARED

In addition to making sure you have the adequate equipment, consider all the other factors that will contribute to the success of your coverage.

- The site. Visit the wedding locale well in advance of the event and scout out places to shoot. What are the best places to shoot formals? Where can you get a good overall shot to set the scene? Where can you set up a camera so you can photograph the ceremony close-up? The more you know about the site in advance, the better you'll be able to take the best advantage of locations.

- The time of day. Obviously, the way you shoot an afternoon wedding will differ greatly from the way you shoot an evening wedding. You may want to take advantage of afternoon light and shoot outdoors as much as possible. On the other hand, an evening wedding will pose some challenges, and opportunities, for creative lighting.

ABOVE: Not every wedding offers the opportunity for a silhouette, but it would be a crime to not take advantage of the backlighting created by natural window light.
28–70MM LENS SHOT AT 28MM, 1/1000 @ f2.8, ISO 200; EXP: AV

RIGHT: Sometimes, your best group portrait will be the shot you made just before everyone was ready. Remember, expression over perfection!
28–70MM LENS SHOT AT 28MM, 1/200 @ f7.0, ISO 200; EXP AV; INCREASED CONTRAST BY 45 PERCENT

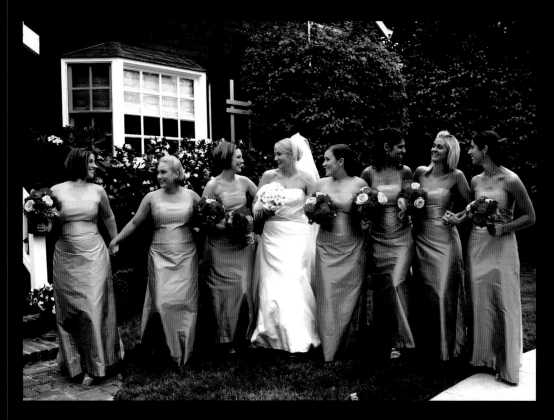

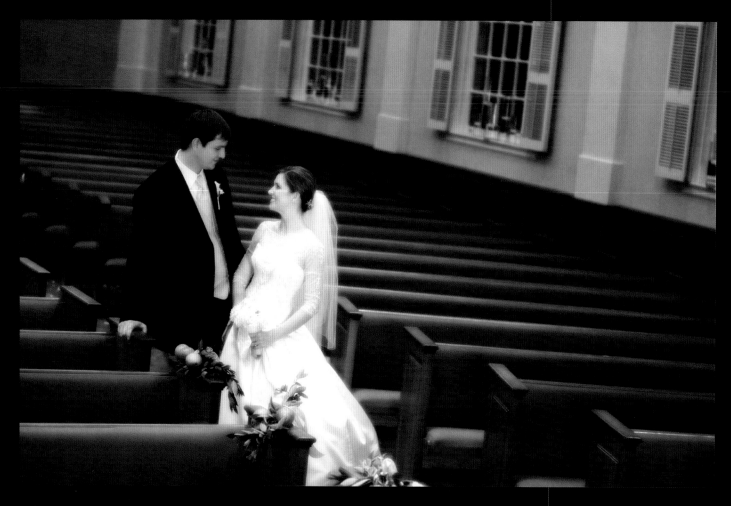

🌿 The weather. **Everyone is going to be worrying about the one thing that no one can control. Check the weather report. If rain is in the forecast, plan accordingly: Abandon plans for outdoor shots, find alternative, indoor locations, protect your camera gear, and be prepared to cope with a little more stress all around.**

🌿 Manpower. **A good assistant is a godsend: He or she can keep track of equipment, move lights, store flash cards as you use them, even download images onto a laptop while you continue shooting. The trick is to find and train an assistant with whom you are completely comfortable and who will know exactly what you need when you need it.**

🌿 The bride's shoes. **As in, what it's like to be in them. Think like the bride and how she must be feeling. What is she worrying most about? Her dress? Seating arrangements at the reception? The more you think like the bride, the better prepared you'll be to focus on what seems to be most important to her. Also, you'll be sensitive to her needs—you'll know when to stay out of her way, when to follow her to capture a moment you might otherwise have missed, how you can help at certain moments of the day.**

No matter how modest the church is, pay attention to the design elements all around you and how they affect your composition.

28–70MM LENS SHOT AT 70MM, 1/25 @ f2.8, ISO 400; EXP: AV

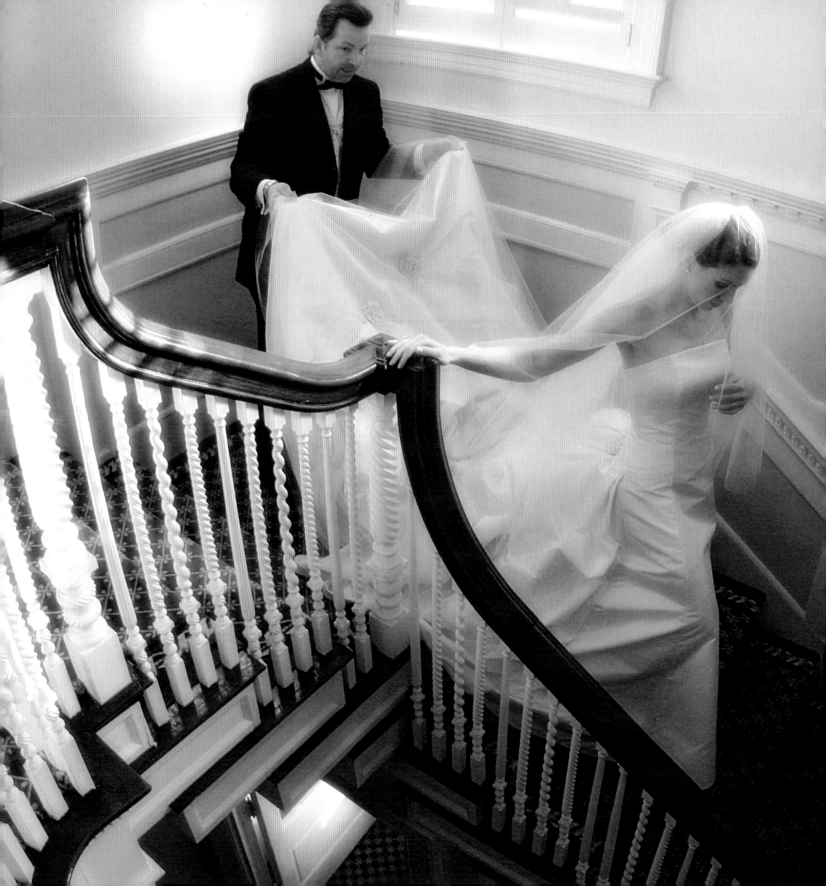

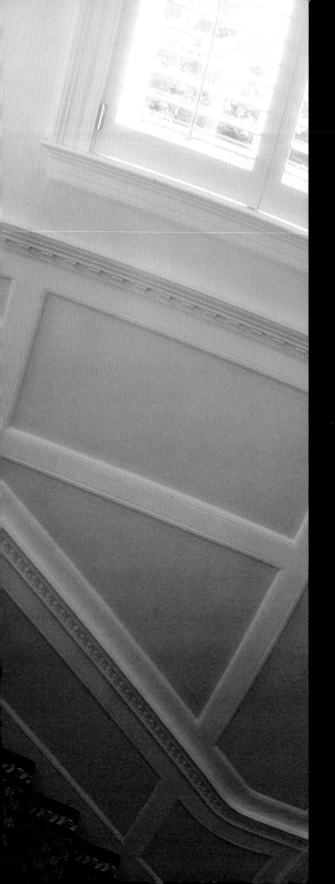

THE EVENT

BEFORE THE EVENT

THE CEREMONY

AFTER THE CEREMONY

ON TO THE RECEPTION

Your job is to give the bride and groom what they deserve: an album that's unique to them. So, capture the emotion and tell the story of the day in a way that no one else could.

BEFORE THE EVENT

If a picture is worth a thousand words, then we're about to present an entire library of ideas.

What's truly incredible is the limits digital photography puts on your creativity—there aren't any! From the way you capture images the first time you meet the couple, the sky's the limit.

Every couple is unique and you have a responsibility to get to know them well from the very start. Quite literally, you need to see the world not just as a photojournalist, but through their eyes.

Embrace the chance to offer coverage beyond the actual ceremony. From a session capturing the excitement of the couple's engagement to the rehearsal dinner to the preparations just before the ceremony, you have many opportunities to celebrate the personalities of this couple and to tell their story. The more you shoot, the better storyteller you'll be, and you'll build additional sales, too.

What's truly incredible is the limits digital photography puts on your creativity—there aren't any!

As a storyteller, your mission is to capture the small moments. If you're male and normally photograph by yourself, this is the time to get a woman involved in your business. A female photographer can capture images in places you can't go, and she can also help put the bride at ease. Meanwhile, you can capture a behind-the-scenes shot of the groom.

RIGHT: 85MM LENS, 1/100 @ f2.8, ISO 400; EXP: AV; CONVERSION TO BLACK AND WHITE

OPPOSITE: 28–70MM LENS SHOT AT 28MM, 1/60 @ f2.8, ISO 200; EXP: AV; NIK MULTIMEDIA FILTER: INFRARED: BLACK AND WHITE

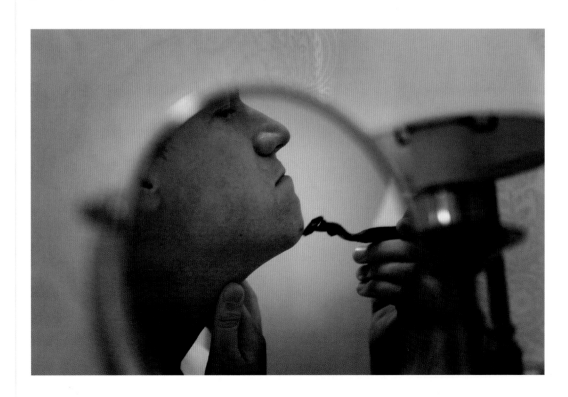

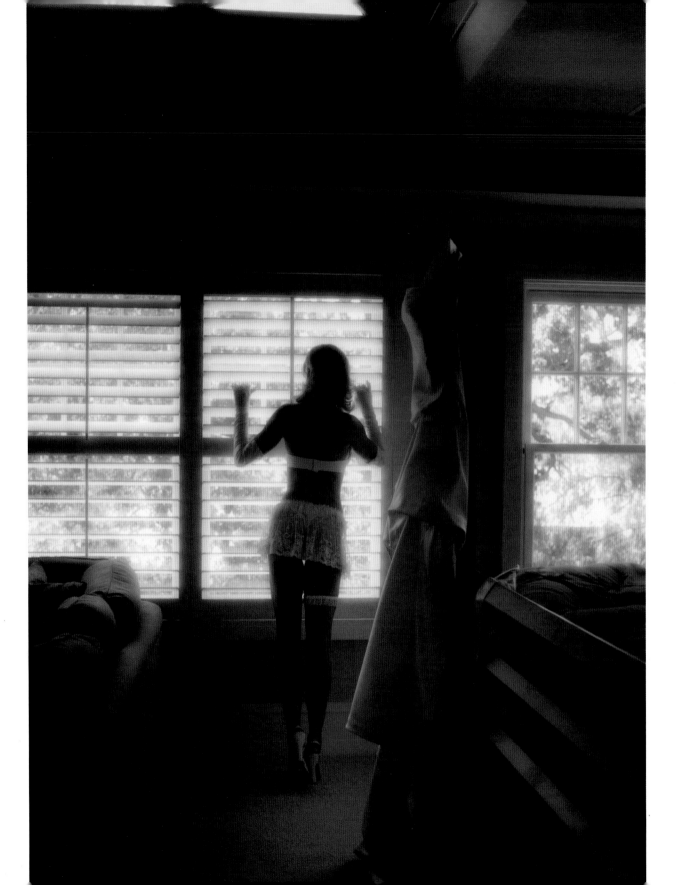

Adding Special Effects

Engagement portraits lend themselves especially well to cross-processing and other special effects, since these can help capture the personality of a couple. Take the image with the settings you normally would, then go to town in the digital workshop. Typically, we experiment with several different Photoshop and nik multimedia filters to add special effects that range from heightening colors to abstracting forms. The trick is to find one that we think reflects the personal style of the couple. Sometimes, though, a straightforward image does that best. For more on special effects, see pages 116–137.

THE ENGAGEMENT SESSION

The engagement session is rife with opportunity, and you should make the most of it!

From a purely practical standpoint, the engagement session is a business opportunity that gives you a chance to create a saleable image months ahead of the wedding. Our clients have purchased these images to use as everything from large wall prints to engagement announcements, Web site pages, and invitations. If you create an image that's truly unique, there's really no end to the ways in which a couple can use it.

Most important, perhaps, the engagement session gives you a chance to spend a few hours getting to know your clients. You can find out where they met, where they live, what they do, what their plans are. All this information will help you get into their mind-set and create a wedding album that captures their personality and style—the essence of who they are as a couple. It's all about appreciating style and listening and understanding the human spirit.

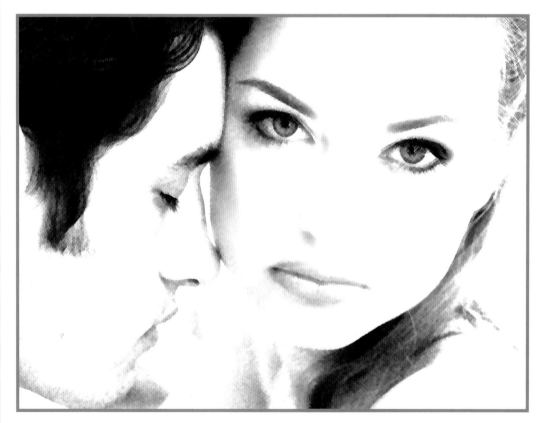

Want to maximize impact of a head shot? Focus on just the faces!

28–70MM LENS SHOT AT 50MM, 1/50 @ f4.5, ISO 200; EXP: AV; NIK MULTIMEDIA FILTER: INFRARED: BLACK AND WHITE

Location can play a big role in engagement-session shots, as the personality of a place can say a lot about the couple, their tastes, and their sense of style. Besides, these sessions provide a chance to shoot in fun locations you often don't otherwise encounter during a wedding shoot.

TOP LEFT: 70–200 MM LENS SHOT AT 70MM, 1/80 @ f3.2, ISO 200; EXP: AV; NIK MULTIMEDIA MONDAY MORNING FILTER

LEFT: 85MM LENS, 1/3200 @ f2.8, ISO 200, EXP: AV; NIK MULTIMEDIA MONDAY MORNING FILTER

ABOVE: 200MM LENS, 1/15 @ f2.8, ISO XXX; EXP: AV; MOTION BLUR FILTER

THE HOURS BEFORE

Don't be afraid to offer coverage beyond the ceremony and reception. Any image you make provides the opportunity to build additional sales, and the more you cover, the more you expand your ability to tell the story well. Many photographers overlook the opportunity to photograph the bride and groom during their final preparations. You don't want to be obtrusive, but if the bride and groom agree to give you access during these tense hours, you're sure to capture some highly emotional moments.

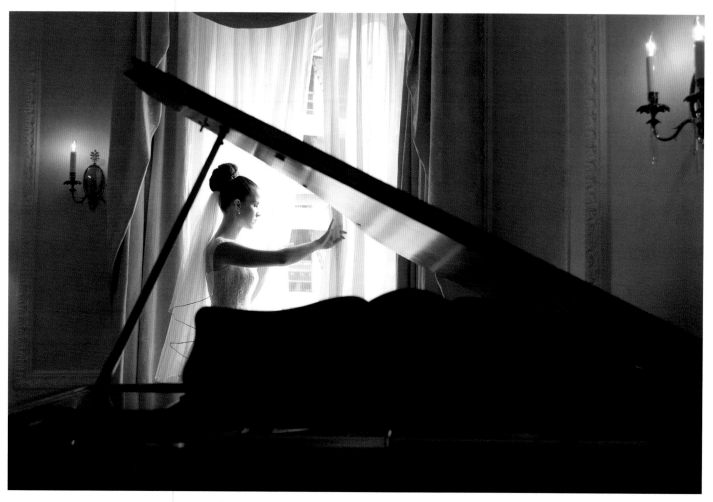

Keep your eye attuned to good composition or for special moments. The lid of a grand piano provides an intriguing structural element to an image that conveys a bride's solitary reflections. A conversation between the bride and a young member of her wedding party provides an image that's sure to melt hearts.

ABOVE: 20–70MM LENS SHOT AT 34MM, 1/400 @ f3.5. ISO 200; EXP: AV; NIK MULTIMEDIA FILTER: DUPLEX

OPPOSITE: 28–70MM LENS SHOT AT 28MM, 1/30 @ f2.8, ISO 200; EXP: AV; NIK MULTIMEDIA FILTER: INFRARED: BLACK AND WHITE, WITH COLOR LAYER

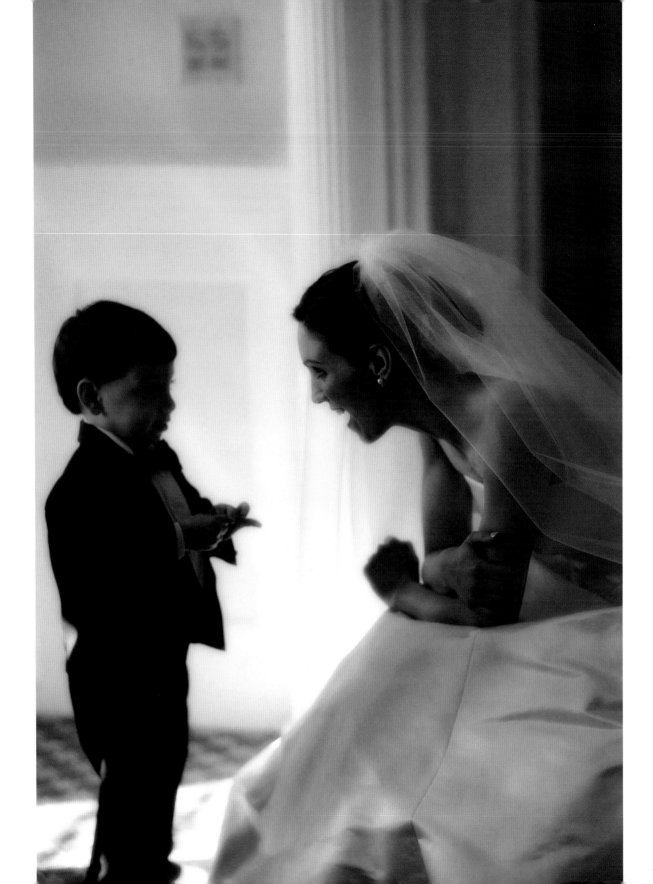

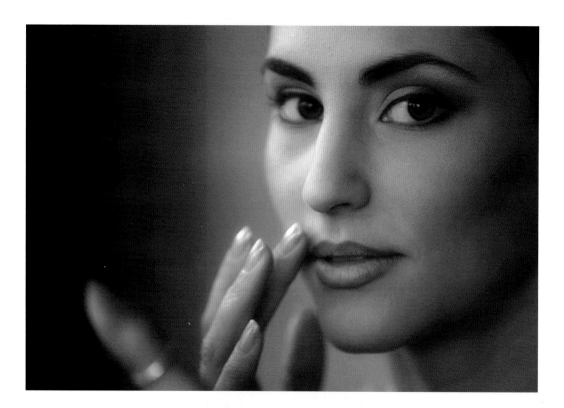

A shallow depth of field and a wide aperture will help you isolate details. A makeup session, for instance, is the perfect time to capture some exquisite eye makeup or an angelic face.

LEFT: 200MM LENS, 1/60 @ f2.8, ISO 200; CONVERSION TO BLACK AND WHITE

BELOW: 85MM LENS, 1/80 @ f2.0, ISO 200; EXP: AV; CONVERSION TO BLACK AND WHITE

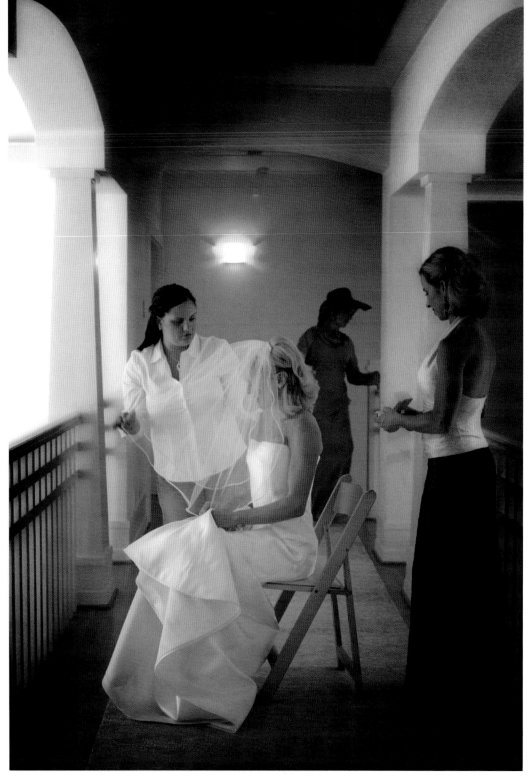

Bring a Variety of Lenses

As you begin shooting the day, be equipped. You should have at least three lenses with you, including a wide-angle and a portrait lens. With a variety of lenses, you will be much more versatile and able to handle any location. As a result, you'll be able to offer your client a broader range of images. Ideally, you should bring a 70–200mm 2.8 IS L, a 28–70mm 2.8 IS L, a 85mm 1.2 L, and a 14mm fisheye.

Don't overlook the obvious. A straightforward shot of final preparations can be informative, too.

85MM LENS, 1/640 @ f1.8, ISO 250; EXP: AV; NIK MULTIMEDIA FILTER: DUPLEX

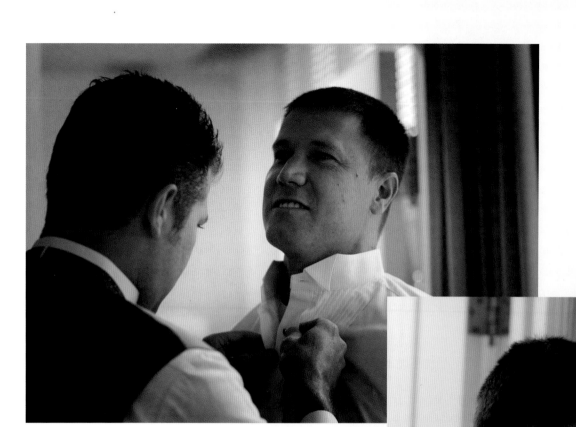

While the bride is definitely the center of attention, don't forget the groom! After all, he's a big part of the story.

ABOVE: 85MM LENS, 1/60 @ f2.8, ISO 320; EXP: AV; CONVERSION TO BLACK AND WHITE

RIGHT: 85MM LENS, 1/100 @ f2.8, ISO 400; EXP: AV; CONVERSION TO BLACK AND WHITE

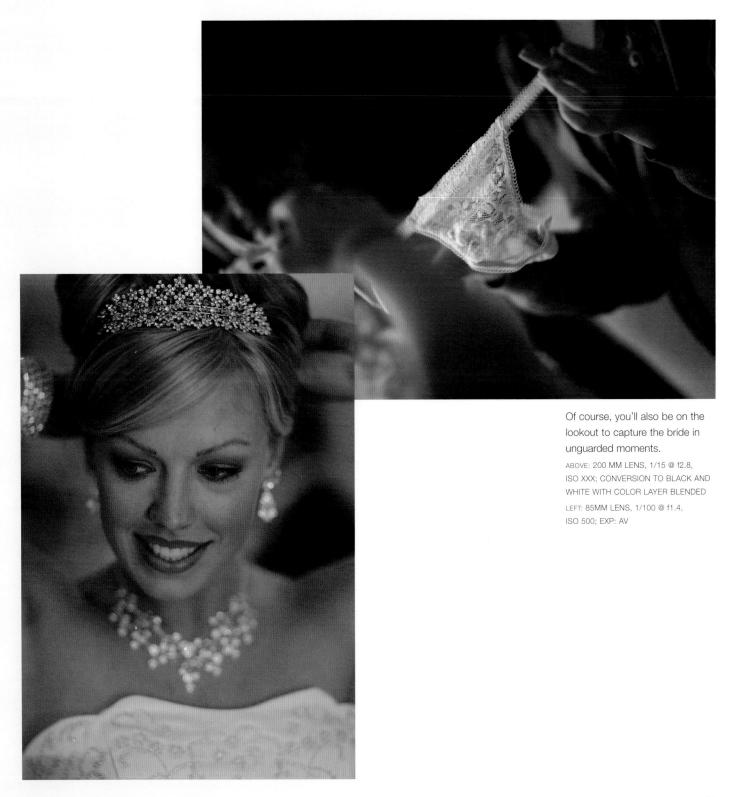

Of course, you'll also be on the lookout to capture the bride in unguarded moments.

ABOVE: 200 MM LENS, 1/15 @ f2.8, ISO XXX; CONVERSION TO BLACK AND WHITE WITH COLOR LAYER BLENDED

LEFT: 85MM LENS, 1/100 @ f1.4, ISO 500; EXP: AV

GET IN THE MIND-SET OF A PHOTOJOURNALIST

Wedding photographers wear two hats: We're portrait photographers, and we're photojournalists. The portrait photographer in us makes the traditional images that deserve a place in any wedding album. In so doing, we pose, direct, and stage manage. As photojournalists, we document the event, and try to stay out of the way while doing so. This way, we don't influence the images.

The more you think like a photojournalist, the better you'll record the emotion of the day. You need to learn how to snap the shutter at just the right moment so you capture the expressions and mannerisms that will make each wedding unique. Start as early in the day as you possibly can and observe everything. When you succeed as a photojournalist, you meet your most important responsibility: recording one of the most important events in your subjects' lives.

70–200MM LENS SHOT AT 140MM; 1/800 @ f2.8, ISO 200; EXP: AV

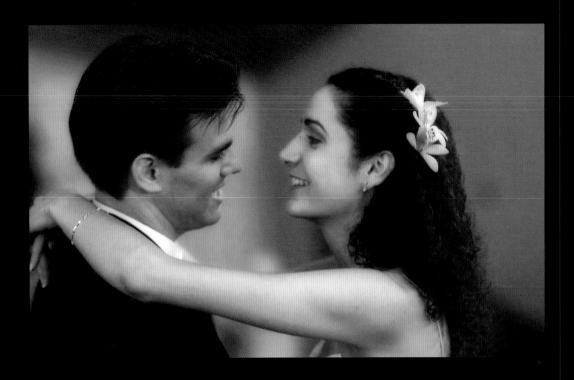

Don't worry about taking too many photos. Your goal is to capture the excitement, romance, sensitivity, emotion, and passion of the day.

LEFT: **70–200MM LENS SHOT AT 200MM, 1/30 @ f2.8, ISO 800; EXP: AV**

BELOW LEFT: **70–200MM LENS SHOT AT 200MM, 1/30 @ f2.8, ISO 800; EXP: AV**

BELOW RIGHT: **70–200MM LENS SHOT AT 200MM, 1/30 @ f2.8, ISO 800; EXP: AV**

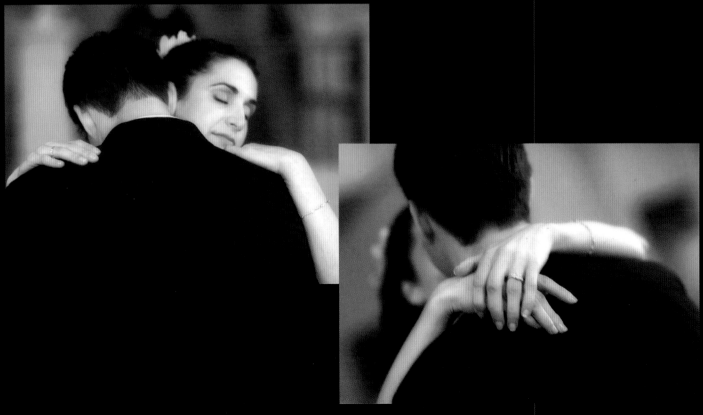

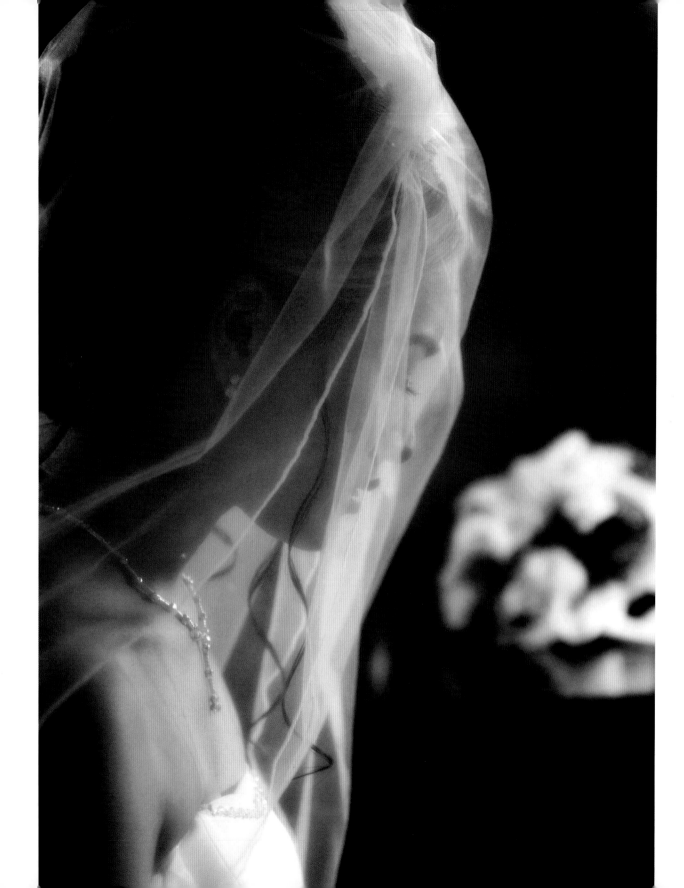

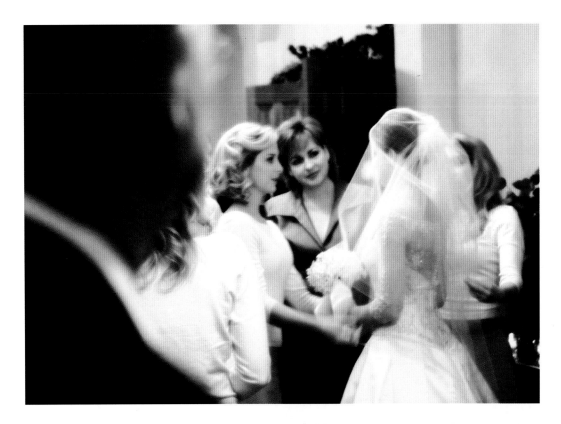

LEFT: 70–200MM LENS SHOT AT 90MM, 1/15 @ f5.7, ISO 1250, EXP: AV, PHOTOSHOP BLACK AND WHITE CONVERSION

BELOW: 200MM LENS, 1/15 @ f2.8, ISO 200; EXP: INFARED

OPPOSITE: 70–200MM LENS SHOT AT 200MM, 1/125 @ f2.8, ISO 200; EXP AV; PHOTOSHOP BLACK AND WHITE CONVERSION

Snap the shutter at just the right moment so you capture the expressions and mannerisms that will make each wedding unique.

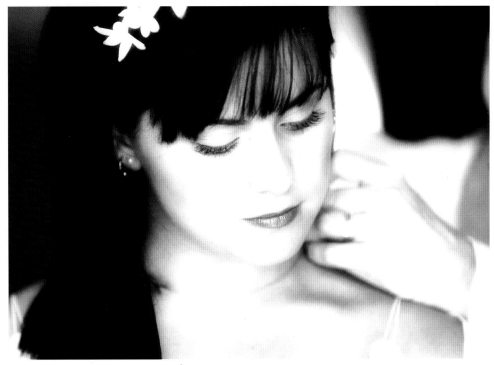

PRE-WEDDING FORMALS

Though they're staged, pre-wedding formals can set the scene in a very real way. You can capture the jitters, the excitement, and all the drama that leads up to the ceremony. In reality, formal doesn't have to mean stiff or overstaged, and pre-wedding formals can go a long way toward capturing the unique personality of a wedding. But this is a tense time for everyone, and you want to be careful not to add to the tension. In fact, you can be a reassuring presence.

This is a tense time for everyone, and you can be a reassuring presence.

Making Sure Pre-wedding Formals Go Smoothly

- Start early. We typically start about three hours before the ceremony. Tell the bride to ask her bridesmaids to be there then, too, with hair and makeup done.
- As soon as you arrive at the wedding venue, find the location you want to use for your formals. The only criterion is to get the most bang for your buck: You want a simple neutral background, outdoors if possible. Preferably, you'll capture the bride and her bridesmaids at the bride's home.
- Keep your client's comfort in mind and try to stay away from setting up light stands (they can be intimidating). Try to use as much natural light as you can.
- Start with the bride by herself, then the bridesmaids. Remember, it takes longer to work with the bride than with the groom. By taking care of the bride first (and preferably, even before you get to the ceremony location), you're not racing against time.

RIGHT: A shot of a nervous groom is always a nice addition to a wedding album.
70–200MM LENS SHOT AT 70MM, 1/125 @ f2.8, ISO 100; EXP: AV

OPPOSITE: The radiant bride may be the subject of this shot, but the portrait also shows off another star of the day, the wedding gown. The column adds some architectural interest and provides a rich yet unobtrusive background.
200MM LENS, 1/15 @ f2.8, ISO 800; EXP: AV

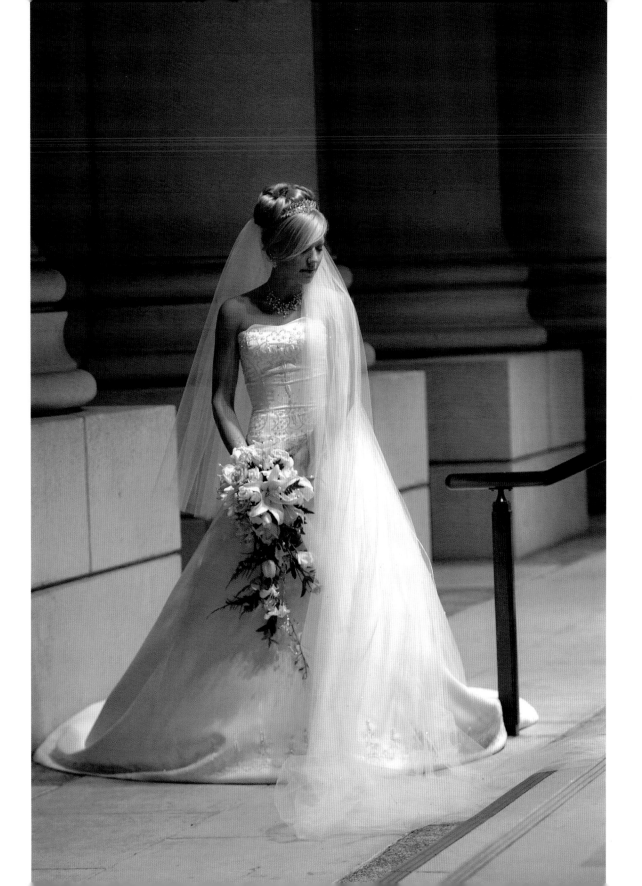

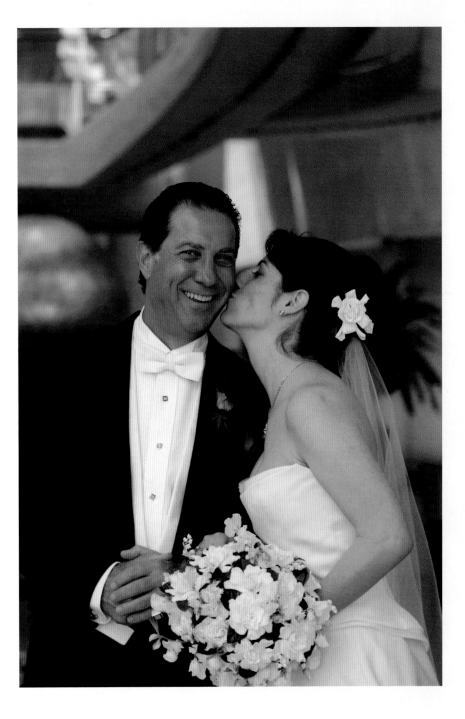

Pre-wedding formals add a lot to your storytelling. Two photos of a bride and her father are fairly straightforward, yet they impart a father's emotion as he is about to give his daughter away.

ABOVE: 70–200MM LENS SHOT AT 100MM, 1/60 @ f2.8, ISO 200; EXP: AV

RIGHT: 70–200MM LENS SHOT AT 100MM, 1/60 @ f2.8, ISO 200; EXP: AV

70–200MM LENS SHOT AT 100MM, 1/60 @ f2.8, ISO 200; EXP: AV

Go Natural

Try bypassing the flash and using available light whenever possible when photographing groups. Equipment, lights especially, tend to intimidate even the most photogenic and willing subjects, so the less equipment you use, the more natural and at ease your subjects will appear. Of course, this is sometimes easier said than done. The quest for natural light may lead you to some interesting locations, another reason why it's so important to scout ahead of time. The payoff is not only your subjects' comfort, but some great backgrounds for your images.

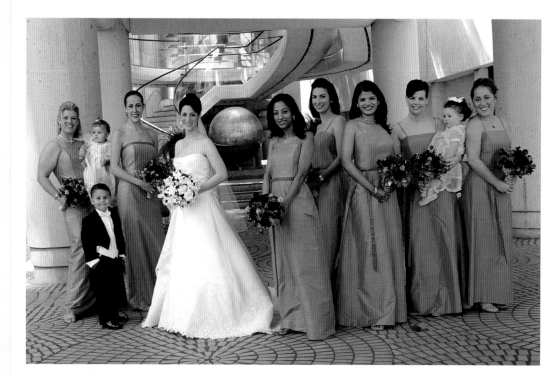

28–70MM LENS SHOT AT 35MM, 1/60 @ f4.5, ISO 200; EXP: AV

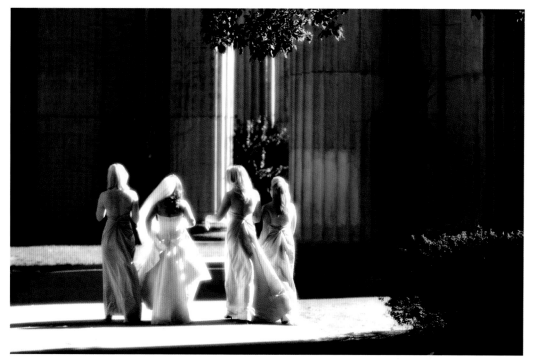

200 MM LENS, 1/125 @ f2.8, ISO 400; EXP: AV

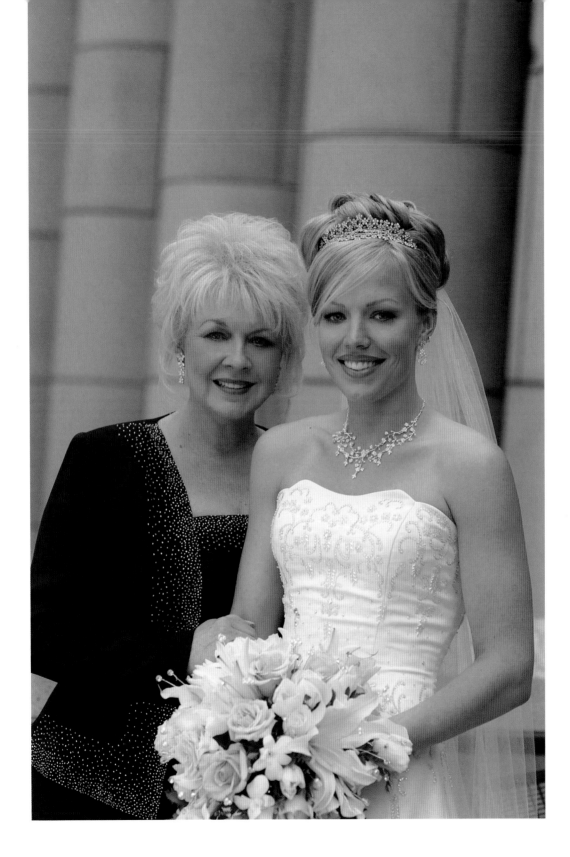

It's hard to get a bride to stand still before the ceremony, so take advantage of the rare moment when she does to focus on the details. A straight-on image shows off some exquisite jewelry, the bridal bouquet, the intricately worked dress, and even this bride's elegant bone structure.

70–200MM LENS SHOT AT 70MM, 1/60 @ f4.0, ISO 200; EXP: AV

THE CEREMONY

The bride and groom won't notice all the emotion floating around the room, but they'll relish the chance to see these images later.

Photographing the ceremony can be the toughest part of the assignment—at least if you're going to do it right. You want to show all the aspects of the ceremony that tell the story and also capture elements of emotion among family and friends. During the ceremony, the bride and groom won't notice all the emotion floating around the room or individual reactions, but they'll relish the chance to see these images later.

Use two cameras for this part of your coverage. An assistant in the front of the church can photograph the procession as it comes down the aisle, while you work the back of the church to capture those precious last moments before the bride heads to the altar. If you're working alone, set up the camera in front on a tripod and use your wireless radio transmitter.

A double-angled approach: With cameras at the front and back of the church, you will be assured of getting the most dramatic impact out of the ceremony.

RIGHT: 28–70MM LENS SHOT AT 28MM, 1/60 @ f5.6, ISO 400; EXP: AV; DOUBLE LIGHTING: FLASH FILLED WITH SIDE LIGHT

OPPOSITE: 28–70MM LENS SHOT AT 30MM, 1/60 @ f5.6, ISO 400; FLASH: VIVITAR 285 @ f5.6; SECONDARY FLASH LEFT AT 45 DEGREE ANGLE @f.4

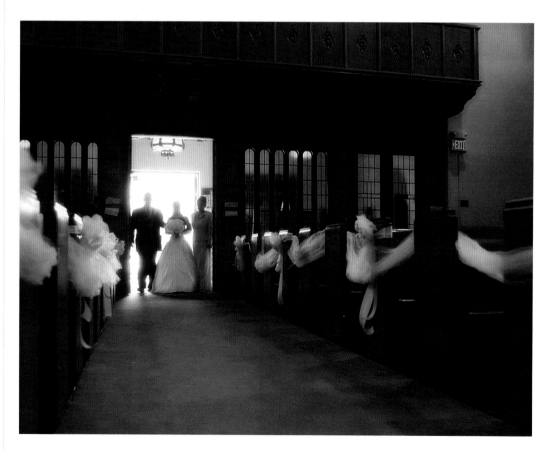

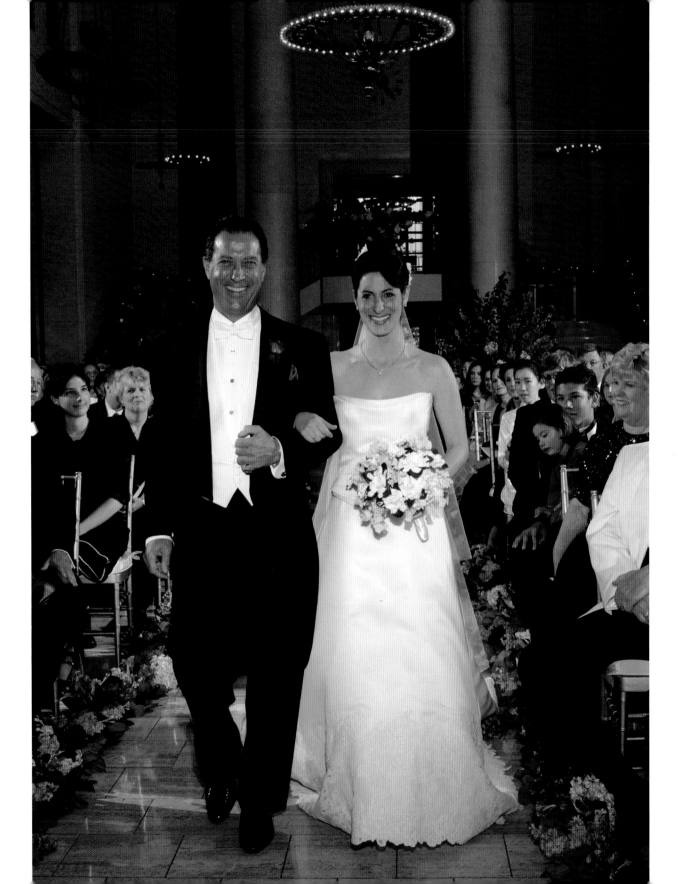

The minutes just before the ceremony are prime time for good storytelling. Play photojournalist and document the moment when the bride gets out of the car and walks up the steps of the church. These scenes are all the more touching because of the attention paid to the dress, and they evoke the closeness of the threesome. A shot through a leaded window adds even more impact to an already dramatic scene.

RIGHT: 28–70MM LENS SHOT AT 53MM, 1/250 @ f8.0, ISO 32; EXP: AV

BELOW: 28–70MM LENS SHOT AT 70MM, 1/250 @ f2.8, ISO 320; EXP: AV

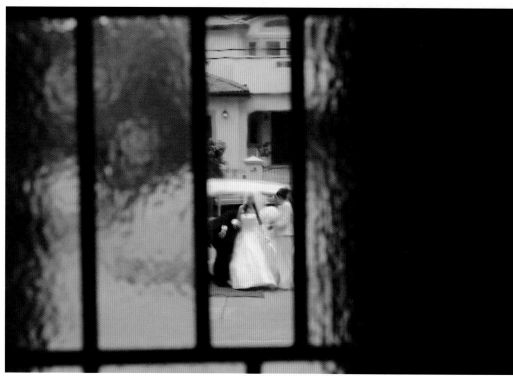

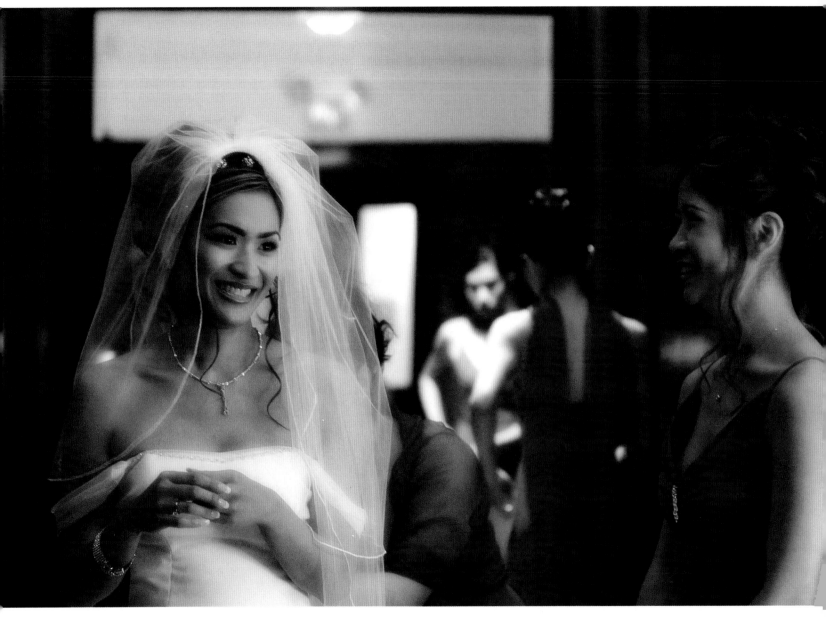

By stationing yourself in the back of the church, you'll be on the scene when impromptu moments like this erupt. This beautiful smile evokes the joy and nervousness of a woman who is about to take one of the biggest steps of her life.

70–200MM SHOT AT 200MM, 1/15 @ f2.8, ISO 1600; EXP: AV

Getting the Best Ceremony Coverage

- Pay attention to the excitement taking place minutes before the bride walks down the aisle.

- For anyone walking down the aisle, shoot both full length as well as tighter head shots. This moment is all about the pure joy of anticipation. If you only shoot full length, you're going to miss some of the best facial expressions of the day.

- Photograph the bridesmaids and groomsmen, too. Many photographers shoot only the bride coming down the aisle, but they miss a lot. Other members of the wedding party betray emotion too, and this will add to your story. Don't worry about filling up those memory cards—that's why you brought so many, and the more you shoot, the more moments you'll capture.

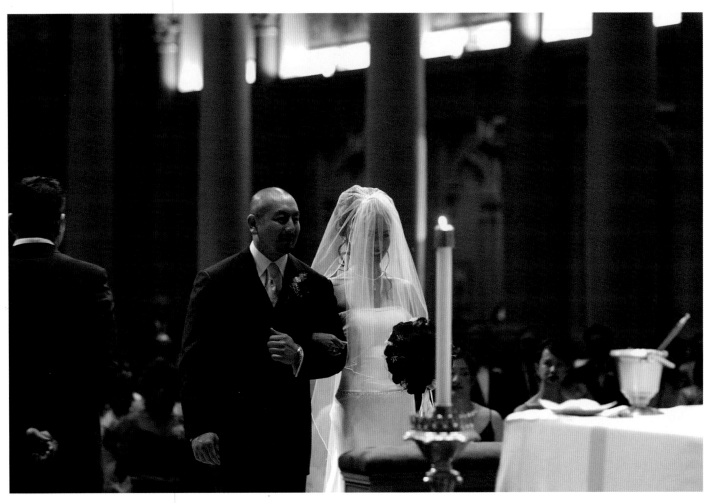

Notice how well black and white documents an intense moment between the bride and groom.

70–200MM LENS SHOT AT 200MM, 1/100 @ f2.8, ISO 1600; EXP: AV

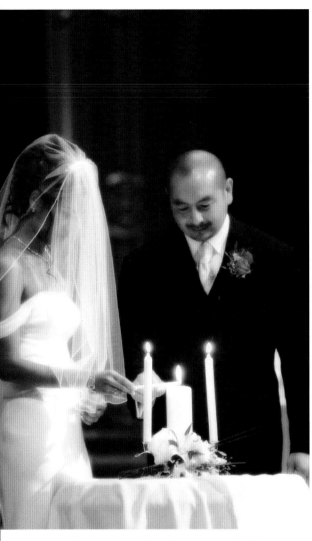

Rituals, such as this veil ceremony in a Philippine wedding (right), are distinctive parts of weddings, and it's important to record them. Grounded in tradition and culture, rituals say a lot about the couple's values. These images are distinctive elements in the final album, and they add another dimension to your storytelling.

ABOVE: 70–200MM LENS SHOT AT 200MM, 1/50 @ f2.8, ISO 1600; EXP: AV; NIK MULTIMEDIA FILTER: DUPLEX

RIGHT: 85MM LENS, 1/40 @ f2.8, ISO 1600; EXP: AV

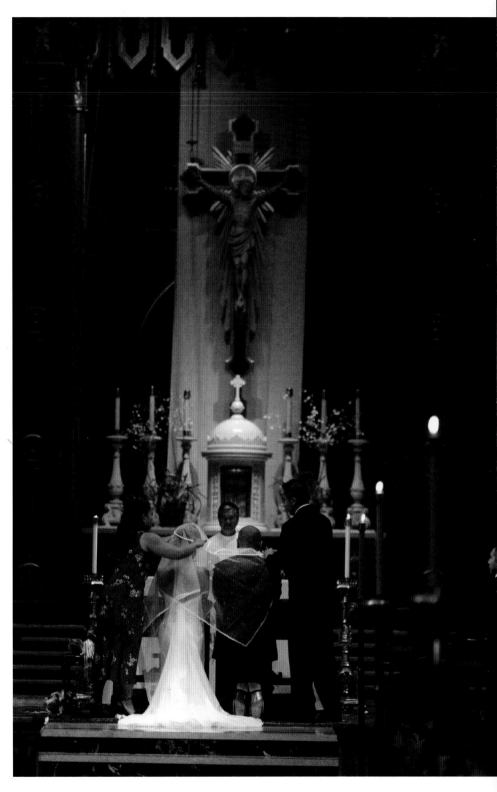

A series of images captures the
"I do" moment, as well as the
drama leading up to it and the
joy following.

RIGHT: 85MM LENS, 1/80 @ f1.2,
ISO 1250; EXP: AV

BELOW LEFT: 85MM LENS, 1/50 @ f1.2,
ISO 1000; EXP: AV

BELOW RIGHT: 85MM LENS, 1/30 @ f1.6,
ISO 1000; EXP: AV

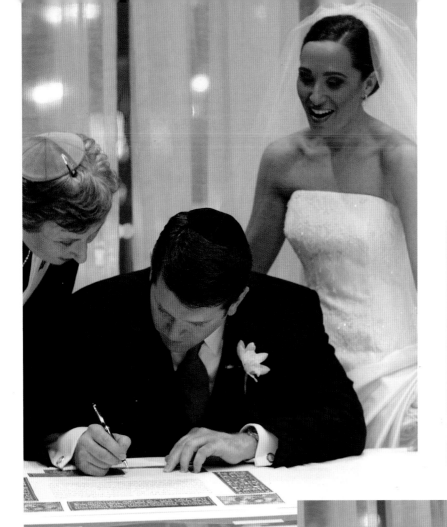

Rituals are distinctive parts of weddings, and it's important to record them.

ABOVE: 70–200MM LENS SHOT AT 200MM, 1/60 @ f 3.2, ISO 1000; EXP: AV

TOP RIGHT: 70–200MM LENS SHOT AT 200MM, 1/80 @ f3.2, ISO 1000; EXP: AV; PHOTOSHOP BLACK AND WHITE CONVERSION

BOTTOM RIGHT: 70–200MM LENS SHOT AT 200MM, 1/60 @ f3.2, EXP: AV, PHOTOSHOP BLACK AND WHITE CONVERSION

ADDING IMPACT

Many photographers only shoot the standard images of the bride and groom. Queen and King for the day they may be, but the story isn't exclusive to them. Bridesmaids, ushers, and guests are all promising subjects, too, as are the intricate little details that you will pick out with your photographer's eye.

28–70MM LENS SHOT AT 70MM, 1/60 @ f5.0, ISO 320; EXP: M; VIVITAR 285 FLASH @ f5.6, SECOND LIGHT AT 45 DEGREE ANGLE ON LEFT

28–70MM LENS SHOT AT 28MM, 1/30 @ f2.8, ISO 400; EXP: AV

28–70MM LENS SHOT AT 35MM, 1/60 @ f2.8, ISO 1600; EXP: AV

28–70MM LENS SHOT AT 35MM, 1/60 @ f2.8, ISO 320; EXP: AV

Guests and members of the
wedding often wear their emotions
on their sleeves, adding a great
sense of drama to the occasion.

ABOVE: 85MM LENS, 1/60 @ f2.0,
ISO 400, EXP: AV; PHOTOSHOP BLACK
AND WHITE CONVERSION

RIGHT: 70–200MM LENS SHOT AT 70MM,
1/15 @ f2.8, ISO 1250; EXP: AV

Observe the facial expressions of others present and you are bound to find emotive images.

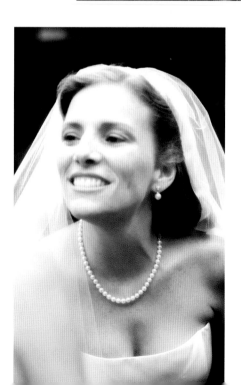

TOP LEFT: 200MM LENS, 1/15 @ f2.8, ISO 200; BLACK AND WHITE CONVERSION

ABOVE: 200MM LENS, 1/15 @ f2.8, ISO 400, EXP: AV; BLACK AND WHITE CONVERSION

LEFT: 85MM LENS, 1/.60 @ f2.0, ISO XXX; BLACK AND WHITE CONVERSION

FAR LEFT: Young guests are prime subjects, sure to find a place in a wedding album.

70–200MM LENS SHOT AT 200MM, 1/125 @ f2.8, ISO 200; EXP: AV

BEAUTY IS IN THE DETAILS

The difference between a good wedding photographer and an average wedding photographer is an eye for details. After all, what is a wedding if not a convergence of thousands of little details, each contributing to the unique quality of the day? Your job is to recognize the details that will contribute to the story of any wedding you are shooting. Sometimes you might need to style a shot to capture a detail; most of the time, though, the secret is simply to have an eagle's eye and find the details in every situation.

70–200MM LENS SHOT AT 160MM,
1/100 @ f4.0, ISO 200; EXP: AV

70–200MM LENS SHOT AT 70MM,
1/160 @ f5.7, ISO 200; EXP: AV

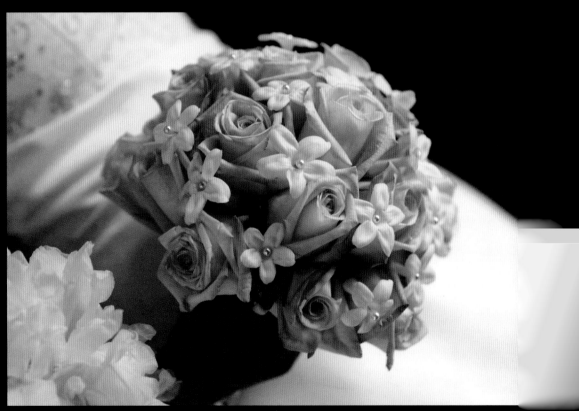

Flowers are not the most surprising subjects for a wedding shot, but they're a crowd pleaser. Shoot them from

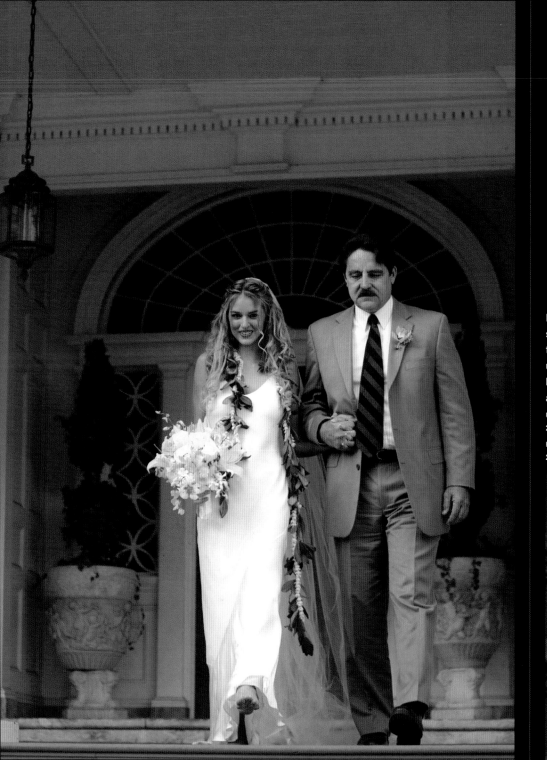

Many photographers try to shoot the bride's shoes, because they are often an exquisite and unnoticed part of the attire. This bride, however, had a surprise, and a fun image, in store.

RIGHT: **70–200MM LENS SHOT AT 200MM, 1/125 @ f2.8, ISO 200; EXP: AV**

BELOW: **70–200MM LENS SHOT AT 200MM, 1/125 @ f2.8, ISO 200; EXP: AV**

AFTER THE CEREMONY

You won't have the opportunity to do outdoor formals at every wedding. Whether or not you do depends on the taste of your clients—and the weather. But outdoor formals are a kick to do and add a more casual editorial look to the final album.

OPPOSITE: 28–70MM LENS SHOT AT 70MM, 1/160 @ f3.2, ISO 200; EXP: AV; CONVERSION TO BLACK AND WHITE

BELOW: 70–200MM LENS SHOT AT 200MM, 1/60 @ f5.6, ISO 200; EXP: AV; CONVERSION TO BLACK AND WHITE

The ceremony is over, and everyone is happy and ready to celebrate. But for you, the pressure is on. Some of the most critical shooting of the entire wedding takes place just after the ceremony, when you do the formal shots. Then there's the reception. Here, your job is to document what is probably going to be the most important party the newlyweds will ever throw, and also to capture the elements that make this event unique to the couple.

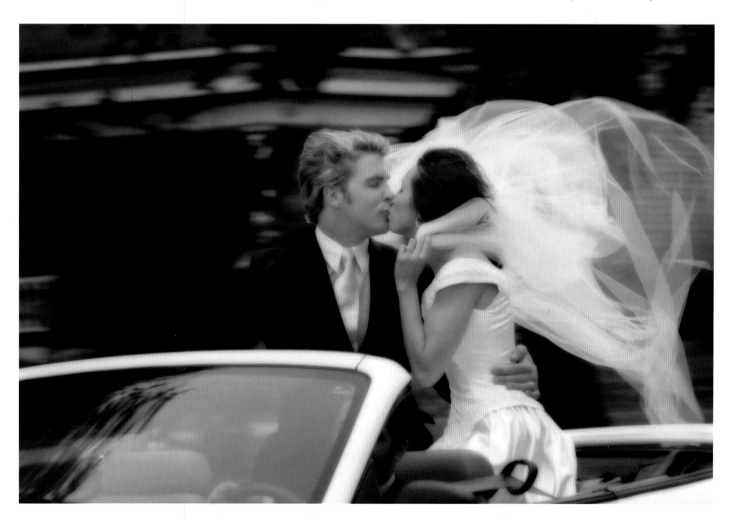

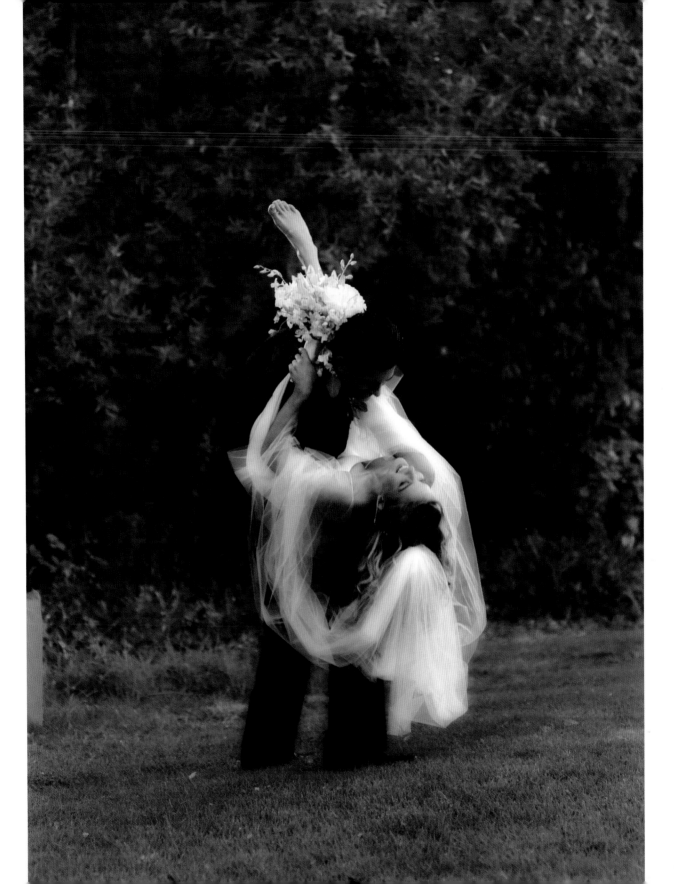

FORMALS

There are countless stories of brides, who no matter how much they love their final album, only remember how long it took to do the formals after the ceremony. All they can talk about is how their photographer spoiled their wedding! Somewhere along the historical road of weddings, the reception became the excuse to entertain the guests while the complete bridal party was photographed. These images are extremely important in the final album, but we don't need to spend all day capturing them. If your assistant has helped you keep everyone together you're about twenty-to-thirty minutes out from the ending of the ceremony and the entire process has been painless. It's time to cut the bride and groom loose and to party!

Making Sure After-Wedding Formals Go Smoothly

- Scout your location well in advance, days or even weeks before.
- When you scout the location, think about the best lens to use with the setting and light conditions. Then, have your camera and lens set up as soon as the ceremony ends so you don't lose a minute. Most of the time you'll be using the 28-70mm lens.
- Start shooting immediately after the ceremony. This is especially important at a church wedding. If you don't photograph the bridal party at this point, it will take you forever to get everyone together at the reception location.

Start with the bride's immediate family. This will allow Mom and Dad to get back to the reception they're typically hosting. Move to the groom and his family next. Now you've got both sides covered and the parents are all on their way to the reception.

ABOVE: 28–70MM LENS SHOT AT 37MM, 1/40 @ f6.3, ISO 400; EXP: AV

RIGHT: 28–70MM LENS SHOT AT 28MM, 1/25 @ f4.0, ISO 500; EXP: M; CANON 580 EX; FLASHES AS BOTH MAIN AND FILL

Next comes the bridal party. Arrange to have them on the sidelines, ready to go the minute you're done with the groom's family.

28–70MM LENS SHOT AT 28MM, 1/250 @ f5.6, ISO 200, ESP: AV, A SINGLE REFLECTOR PROVIDED THE MAIN LIGHT

Once you're done with the bridal party, just have the groomsmen step out of the photograph. For the most part, your bridesmaids are still posed nicely. The groomsmen come next.

LEFT: 28–70MM LENS SHOT AT 28MM, 1/30 @ f5.6, ISO 200; EXP: AV

BELOW: 28MM LENS, 1/125 @ f5.6, ISO 100; NIK CROSS PROCESS WITH BLACK AND WHITE BACKGROUND

OPPOSITE: 14MM FISHEYE LENS, 1/60 @ f5.6, ISO 400; EXP: AV

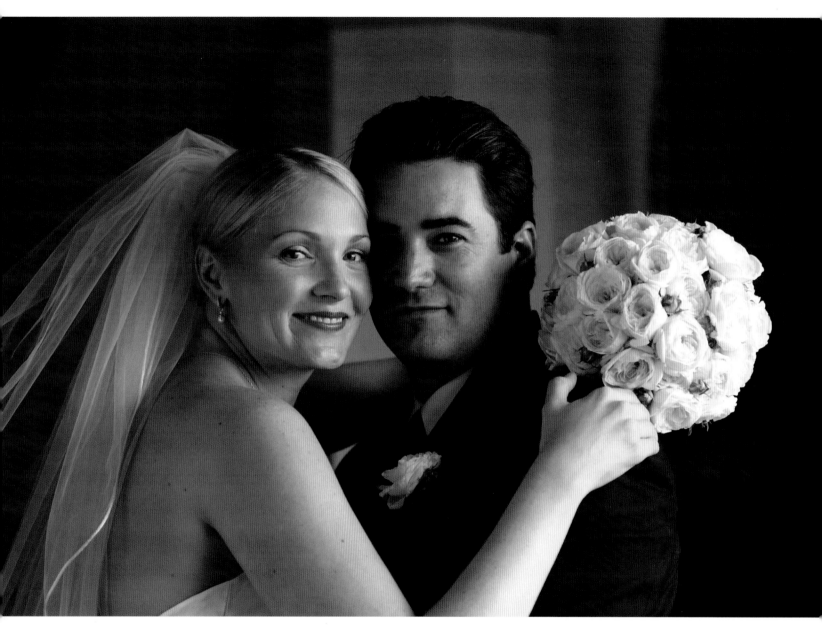

Last but not least are formal shots of the bride and groom. Finally, when the family and bridal party have headed off to the reception, seize the moment and photograph the bride in all her finery. Before you snap the photo, though, arrange her gown so you show it off to its best advantage.

ABOVE: 70–200MM LENS SHOT AT 75MM, 1/200 @ f2.8, ISO 400; EXP: AV

OPPOSITE: 28–70MM LENS SHOT AT 28MM, 1/40 @ f5.6, ISO 400, EXP: M; QUANTUM QFLASH @ f5.6, FILL WITH VIVITAR 285 @ f4.0

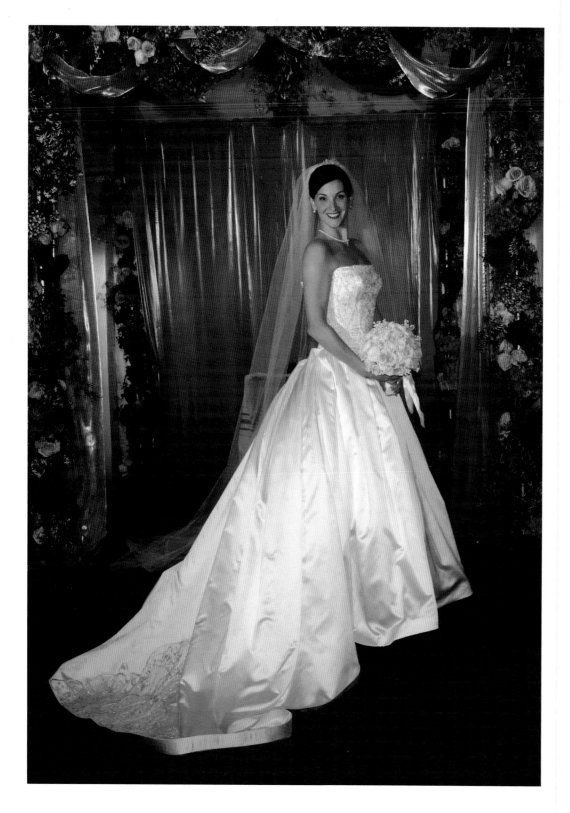

Firing the Best Flash

When doing formals in an indoor location, use Quantum Qflash as your main flash; have your assistant hold the flash and fire it with a Quantum radio slave. Use the Metz50 set at f5.6 for fill flash. Whether you're shooting indoors or out, set your shutter speed based on ambient reading. While we try to use natural light when shooting informal group shots (see page 72), this isn't a concern with formals. The bride, groom, and their families will be expecting a flash or two, and the important consideration with these shots is getting the best possible lighting.

INFORMALS

Informals provide a nice alternative to formal images and offer a chance to capture some attitude. It's not just the poses that are informal—the entire feel of the image is relaxed. In creating your informals, don't be afraid to violate all the rules of composition or to experiment with angles, colors, focus, filters, and all the digital tools at your disposal.

RIGHT: For the first time during the day, the bride seems relaxed; a filter enhances the moody feeling. 85MM LENS, 1/160 @ f2.3, ISO 200, EXP: AV, NIK MULTIMEDIA FILTER: DUPLEX COLOR

OPPOSITE: Whether purely spontaneous or slightly contrived, and however you might eventually process the image, you've got to be ready to capture the moment. 200MM LENS, 1/125 @ f2.8, ISO 100; EXP: AV

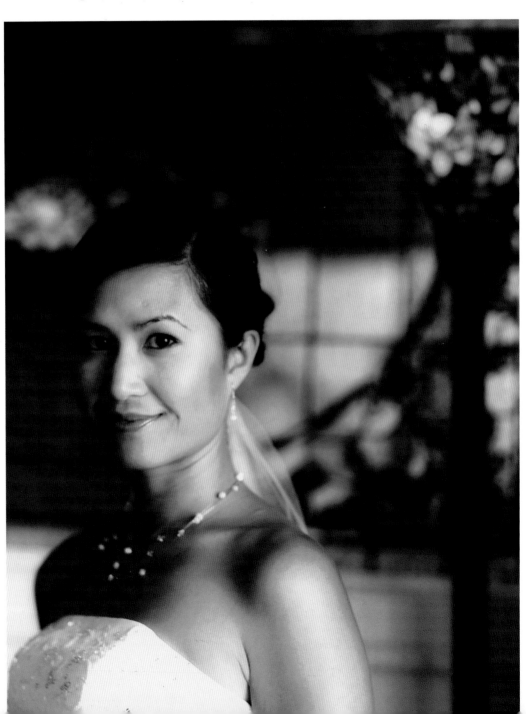

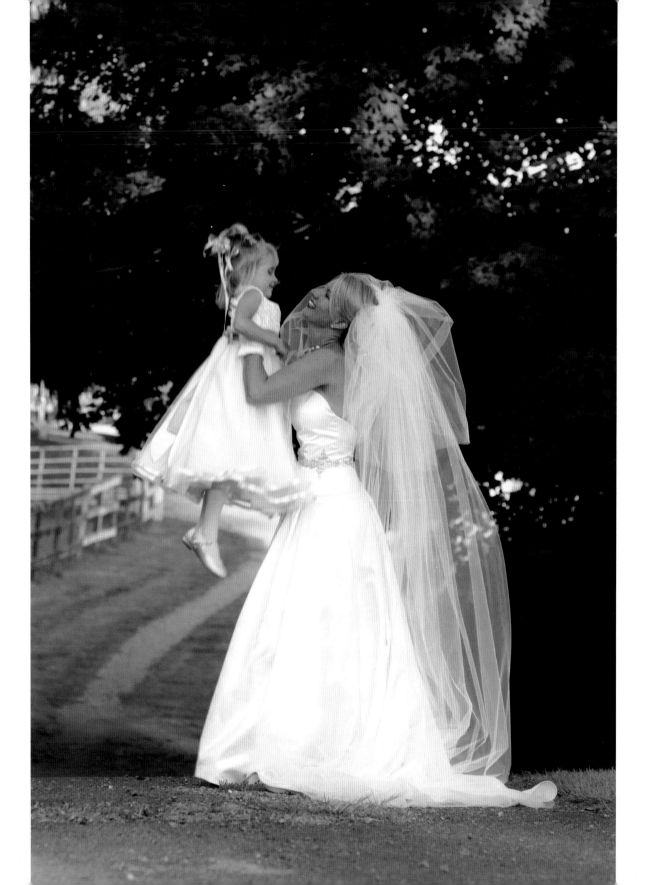

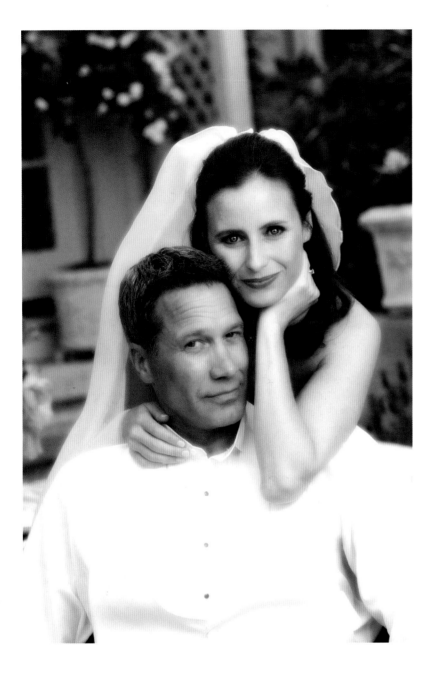

Let the groom take off his jacket and tie—this is one sure way to get a relaxed look. You should also ask the couple to assume a pose in which they feel natural, like themselves. You'll be surprised at what you get, from the somewhat dramatic pose at left to the casual, familiar pose below. Black and white lends a strong graphic quality to these images.

LEFT: 70–200MM LENS SHOT AT 200MM, 1/60 @ f2.8, ISO 200; EXP: M; NIK MULTIMEDIA FILTER: INFRARED: BLACK AND WHITE

BELOW: 70–200MM LENS SHOT AT 70MM, 1/100 @ f3.5, ISO 200; EXP: AV

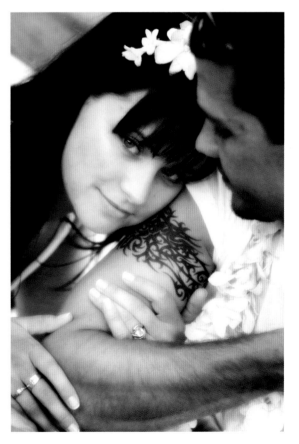

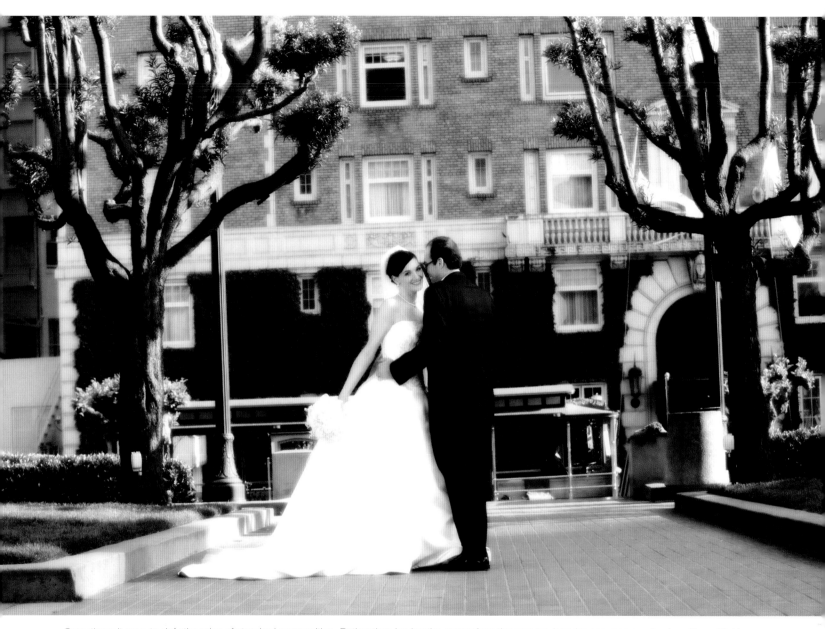

Sometimes it pays to defy the rules of standard composition. Rather than having the groom face the camera, here he assumes a natural position with his bride that conveys closeness. Meanwhile, the bride's extended arm creates a strong line that extends down the length of her gown.

70–200MM LENS SHOT AT 70MM, 1/250 @ f6.3, ISO 200; EXP: AV; NIK MULTIMEDIA FILTER: INFRARED: BLACK AND WHITE

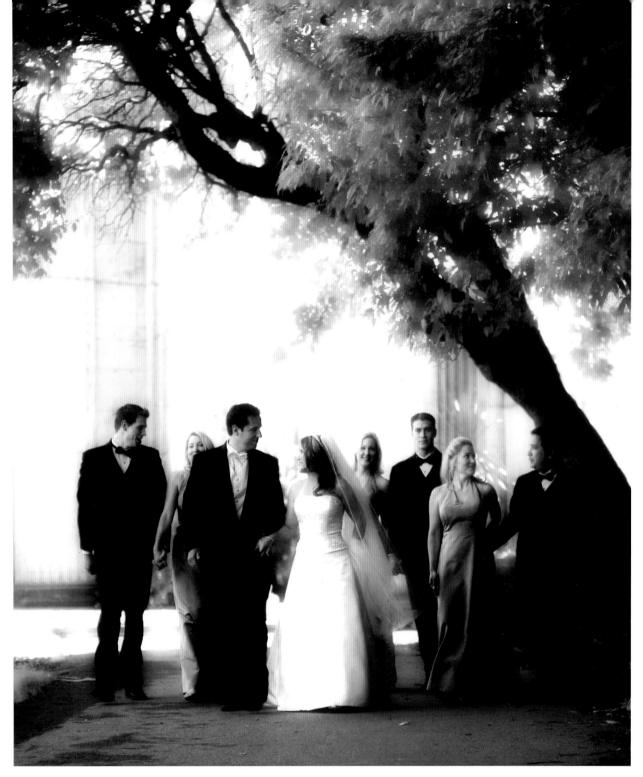

Play director when you shoot informals. By having the group walking, with the tree overhead and the strong lines of the church behind, we imparted energy and strong visual appeal to this shot.

70–200MM LENS SHOT AT 70MM, 1/400 @ f2.8, ISO 200; EXP: AV

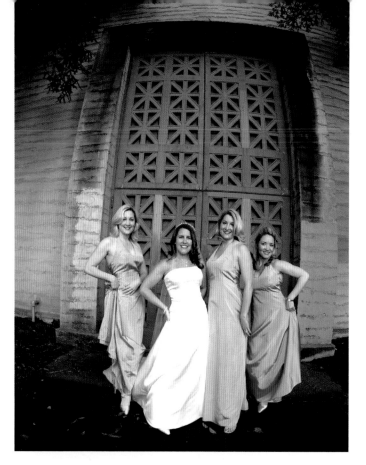

LEFT: Some saucy attitude from these subjects adds plenty of spice to what could have been a static bride-and-bridesmaids shot. A visually interesting backdrop and some cross-processing and heightened contrast accentuates the blue satins and adds additional graphic appeal.

14MM FISHEYE LENS, 1/320 @ f2.8, ISO 200; EXP: AV; CROSS-PROCESSED IN PHOTOSHOP, WITH CONTRAST INCREASED BY 40 PERCENT

BELOW: Just asking the guys to relax can result in a natural-looking image that's preferable to an overly poised shot.

28–70MM LENS SHOT AT 28MM, 1/160 @ f5.6, ISO 200; EXP: AV

Using Fill Flash Outdoors

Fill flash, which brightens the foreground and in so doing evens out light coming from the background, can help you achieve a more natural look when shooting outside. Set the strobe one stop below your ambient light reading. For example, if the ambient light reading is f5.6, set the fill flash at f4.0. Set the Quantum Qflash on manual.

CARS AS PROPS

A vintage car adds interest to a bride-and-bridesmaids shot. Don't be afraid to use a prop this obvious to its full advantage. By seating two of the subjects on the front fender, we made the car an integral part of the image.

28–70MM LENS SHOT AT 43MM, 1/100 @ f4.0, ISO 200; EXP: AV

Vintage cars, luxury cars, downright decadent cars are often a big part of a wedding budget.

So, why not show them off? All those shiny surfaces have great reflective qualities that can add a lot of impact to images. Plus, when shot right, cars have a certain moody quality and their presence in a wedding album seems to suggest that a couple is eager to step on the gas and head into a new life together.

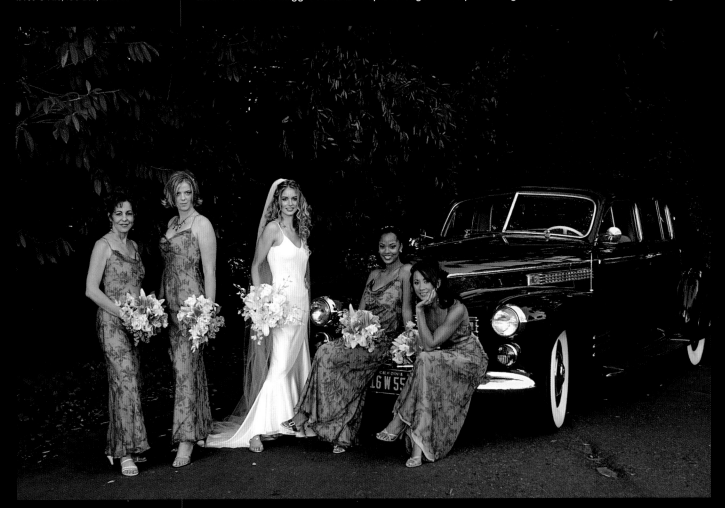

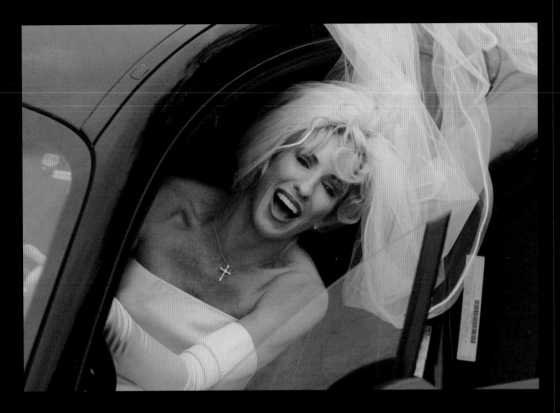

By putting this ebullient bride behind the wheel and tilting the camera a bit, we seem to have captured the excitement of a woman who's ready to charge ahead into her new life.

85MM LENS, 1/125 @ f5.0, ISO 200; EXP: AV

70–200MM LENS SHOT AT 120MM, 1/60 @ f4.5, ISO 200; EXP: AV; NIK MULTIMEDIA FILTER: MONDAY MORNING

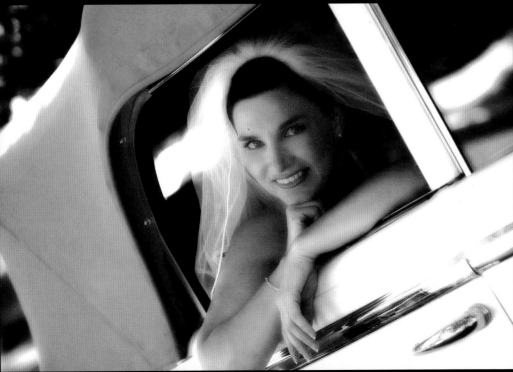

ON TO THE RECEPTION

Once the ceremony is over, there's only one theme on which you'll be creating your images:

They will all be about celebration. At the reception, your challenge is to be unobtrusive and capture the excitement in the air—while trying not to direct or create it.

The opportunities to create exciting reception images are endless. The trick of good reception coverage is to capture the details and the nuances. Your reception images will tell a story of celebration, of families coming together, of a new couple joyously beginning their life together. Seemingly endless, too, are the combinations of lighting, shutter speeds, apertures, and other techniques and technical considerations you can use, from dragging the shutter on the dance floor to working off the videographer's light. Most important, don't miss the moments that capture the essence of this magical event.

The reception hall won't look as good again as it does in the moments before the crowd descends—the candles are still tall, the place settings perfect, the flowers fresh.

TOP: 70–200MM SHOT AT 200MM, 1/50@ f1.8, ISO 800, EXP: AV

ABOVE: 70–200MM LENS SHOT AT 185MM, 1/160 @ f2.8, ISO 400, EXP: AV

RIGHT: 28–70 MM LENS SHOT 28MM, 1/30 @ f4.0, ISO 200; EXP: M; QUANTUM QFLASH @ f4.0 WITH VIVITAR 285 A f2.8

Chances are you can get some candid smiles from the bride and groom during a toast.

85MM LENS, 1/15 @ f1.2, ISO 1600; BLACK AND WHITE CONVERSION

Some of the elements that Bambi tries to capture at any reception include:

- The setting. An enormous amount of time, care, and expense have gone into creating this special atmosphere. So, you want to show the room, the table settings, the floral arrangements, and all the other details off to the best advantage.

- Table shots. These document the guests attending the event. Try not to shoot while the guests are eating; the best time may be just after the guests have been seated and before the meal has been served. The table will be fresh and still beautifully set then, too.

- The toast. Care less about making the standard shot of glasses being raised and more about the very real human emotions that inspire these honors and good wishes.

- The first dance. Since you have a little time to shoot this experience, try different lenses and angles.

- Cutting the cake. Cake shots are fun, but remember, the emphasis is on the interaction of the bride and the groom, and not on the confection itself—you should have photographed the cake earlier.

Capture the details and the nuances. Tell a story of celebration.

Hone Your Skills

Ever photograph a football game? A good sports photographer learns to anticipate the action and knows when to click the shutter. Photographing a wedding reception is no different. In fact, we've seen a few receptions that made the Super Bowl look tame! One terrific exercise to fine-tune your skills is to watch the raw footage of the video of any wedding you've previously photographed and compare it to your images. Were there moments of pure expression you missed? Scenes you wish you had captured? A little detail that would have enhanced your storytelling? You can't catch every moment at a wedding, but if you are aware of what to look for and prepare yourself to react quickly when opportunities present themselves, you'll do a better job.

You can almost feel the father of the bride choking up as he gives his speech. Clearly, it was worth keeping an eye on this emotive fellow, because soon afterwards we caught a wonderfully unguarded moment on the dance floor.

ABOVE: 70–200MM LENS SHOT AT 135MM; 1/25 @ f8.0; ISO 200; EXP: M

RIGHT: 28–70MM LENS, 1/30 @ f5.6; ISO 400; EXP: M

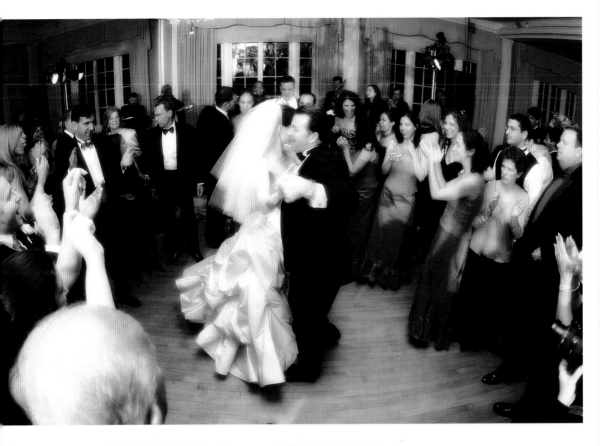

Use the Fisheye Lens, But Sparingly

At the reception, you'll probably want to do some shots of the overall scene, and this is where a fisheye lens comes in handy. The fisheye is especially useful for shots on the dance floor or anywhere else you want to capture a sense of the crowd. As with any special effect, though, use the fisheye lens sparingly, because you don't want too many dramatic shots like this in the album.

ABOVE: A fisheye lens and fill flash capture motion in this image of a wedding standard, the first dance.
14MM FISHEYE LENS, 1/15 @ f4.5, ISO 200; EXP: M; FLASH FILLED

LEFT: You can count on the guests to be more relaxed, and up for a fun pose, after some toasts have been raised.
28–70MM LENS SHOT AT 28MM, 1/25 @ f6.3, ISO 200, EXP: M, FLASH VIVITAR 285 ON AUTOMATIC

Watching the room for good moments pays off. Notice, too, just how much emotion an unposed smile can convey.

LEFT: 85MM LENS, 1/25 @ f1.2, ISO 800; EXP: AV

BOTTOM LEFT: 85MM LENS, 1/40 @ f2.0, ISO 3200; EXP: AV; PHOTOSHOP BLACK AND WHITE CONVERSION

BELOW: 85MM LENS, 1/20 @ f1.2, ISO 800; EXP: AV

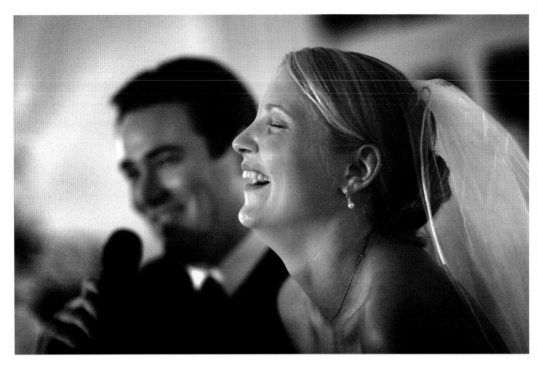

85MM LENS, 1/60 @ f1.2, ISO 1250; EXP: AV; PHOTOSHOP BLACK AND WHITE CONVERSION

Gear Up for the Reception

For any flash photography during the reception use zone focus, which allows you to set your camera and snap away in fast-moving situations (see page 38). Have two cameras ready to go at all times. One should have a fast lens and be set with a higher ISO; the other will be set up with flash and one of your other lenses.

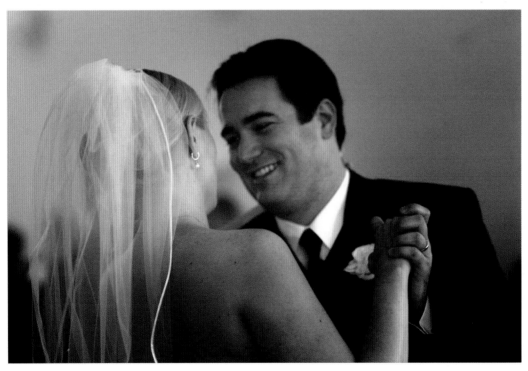

85MM LENS, 1/100 @ f1.6, ISO 800; EXP: AV; PHOTOSHOP BLACK AND WHITE CONVERSION

70–200MM LENS SHOT AT 200MM,
1/160 @ f2.8, ISO 200; EXP: AV

Cake shots are fun,
but remember, the
emphasis is on
the interaction
of the bride and
the groom.

A Few Tips to Get You Through the Reception

- Get your table shots early; once the food is served you'll never get a decent-looking image.
- Don't expect to be fed. Most brides will remember to make sure you get something, but keep a stash of protein bars on hand just in case.
- It may seem incredibly basic, but don't leave your equipment lying all over the room. Keep all your gear in one spot, and give your assistant the job of keeping an eye on things.

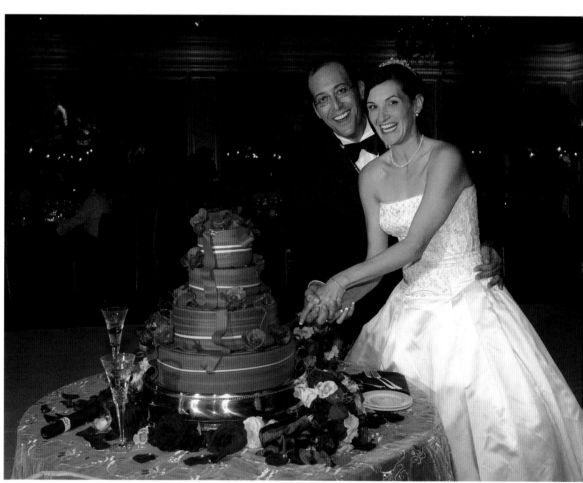

Cake shots deserve a place in any album, but showing off the colors and detail of the confection can be a challenge. The trick is to create shadow detail on the cake while having plenty of light to fill in the rest of the image, too. Double lighting is the answer: Set your main light on one side of the cake, and use on-camera flash for fill flash.
28–70MM LENS SHOT AT 35MM, 1/25 @ f5.6, ISO 400; EXP: M; FLASH FILLED, DOUBLE LIGHT

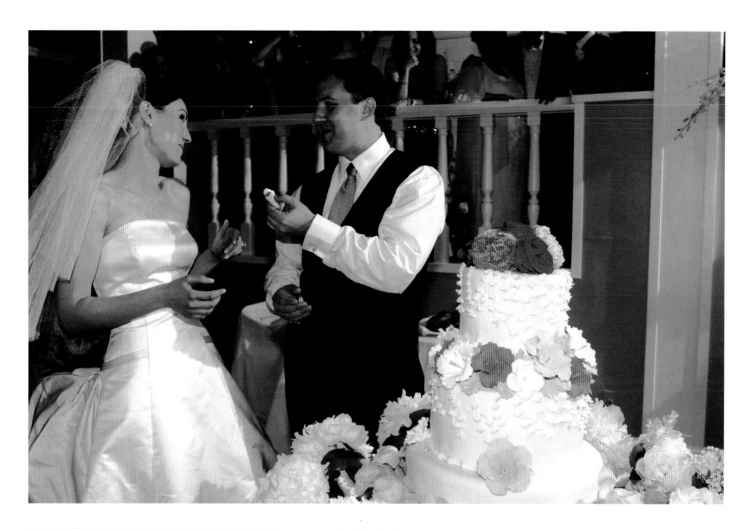

You've already created the images showing off the cake as a thing of beauty. Now's the time to stand back and capture the drama and humor of the first bite.

ABOVE: 28–70MM LENS SHOT AT 35MM, 1/30 @ f8.0, ISO 200; EXP: M

LEFT: 85MM LENS, 1/80 @ f1.4, ISO 400; EXP: AV

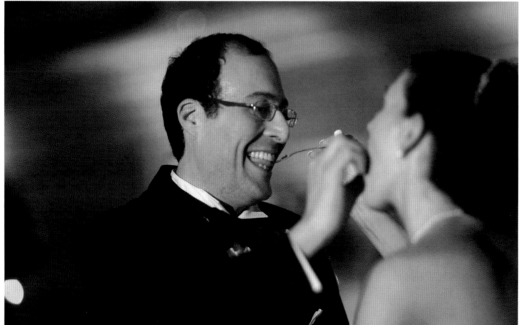

MANIPULATING THE IMAGE

ESTABLISHING WORKFLOW

BLACK AND WHITE

CROSS-PROCESSING

INFRARED

OTHER FILTERS

With digital technology, you can add just about any effect after you've snapped the image. In fact, with the right tools, an otherwise ho-hum image can become a real screamer.

ESTABLISHING WORKFLOW

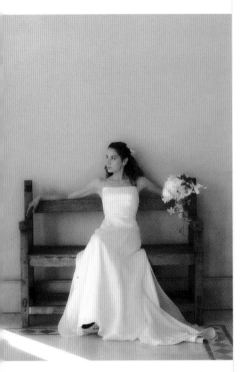

Once you get to work with software, you'll discover just how greatly different filters can alter the feeling of image.

ABOVE: 70–200MM LENS SHOT AT 200MM, 1/125 @ f2.8, ISO 200, EXP: AV; NIK MULITIMEDIA FILTER: MONDAY MORNING

OPPOSITE: 70–200MM LENS SHOT AT 200MM, 1/125 @ f2.8, ISO 200; EXP: AV; NIK MULTIMEDIA FILTER: DUPLEX

Meanwhile, back at the studio: Your first post-wedding project is to load your client's images into a folder on your computer. We recommend loading all your Raw files into Phase One software and grouping them into seven files: Preparations, Group Formals, Ceremony, Reception, Bride and Groom, Details, and Photographer's Favorites. Obviously, you can set up as many files as you want and call them whatever you want. The point is to set up a naming system and be consistent from event to event, so organizing becomes a familiar and easy task. Plus, by using the same nomenclature for the different weddings you shoot, you'll always know where to look for an image from any wedding.

The next step is to rename all the images in each folder. For example, all images categorized as "Preparations" will start with P. Begin with "P01" and continue consecutively through the folder. The first image in the "Details" folder will be "D01" and so on.

Once the designated images are in each folder, we like to use Phase One to edit the images. Phase One presents all the images in a folder as thumbnails on a single screen, so you can see all the images at the same time, and the software also enables you to enlarge each image and examine it carefully. It's time to remove all the duds, the images that you know won't be saleable. If you took three shots of the same subject, pick the best of the bunch.

Now it's time to white balance each batch of images. Remember that ExpoDisc shot we wanted you to take each time the scene changed (see page 30)? Here's where it pays off. With Phase One's batch-processing, you can follow the easy user interface to color balance all your images taken under the same basic lighting conditions at the same time.

This is also the perfect time to introduce black and white to your files. Review all your files and select an appropriate number of images (there's no set amount) that you feel will have more impact as black and white. (Some cameras allow you to capture in black and white, but we shoot in color, so we have the option of deciding later which version to show the client.) Look at the images, too, with an eye to how they might benefit from increased saturation, infrared treatment, and other special effects. We cover these treatments on the following pages. Once you convert the selected images, put them back in order in the proper file folders.

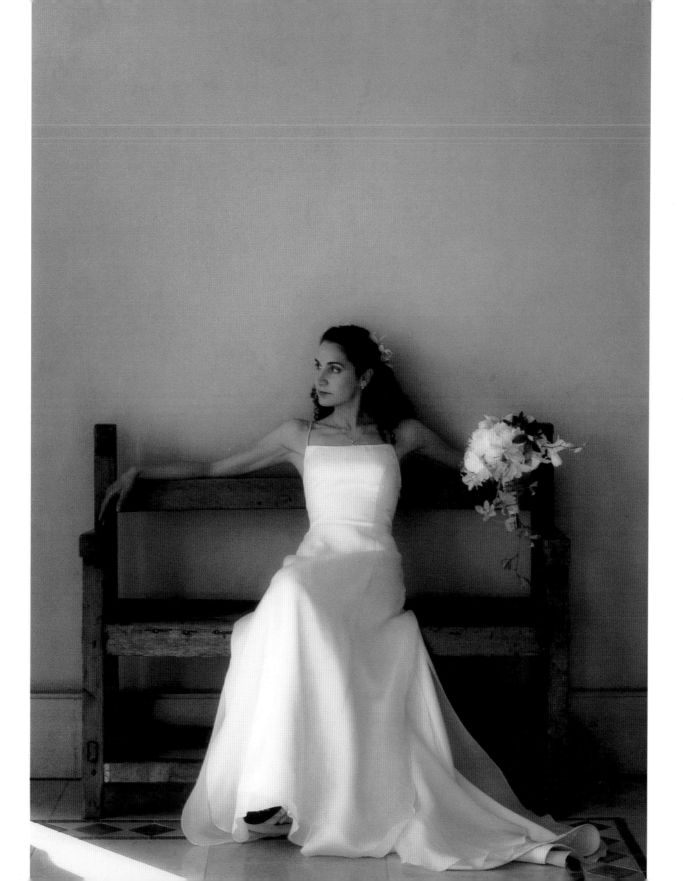

BLACK AND WHITE

A black-and-white treatment can strengthen an image, largely because black and white captures pure emotion without the distraction of color. While it's possible to shoot images in black-and-white mode, we prefer to shoot in color and manipulate the images in Photoshop. This approach has two advantages: We can offer the client the option of color or black and white, and we can determine which way an image will work best.

The first step is to pull the image into Photoshop and do an assessment to see if you think it is a candidate for black-and-white treatment. Does it have tones and lines that black and white will accentuate? Could black and white bring out a certain mood or level of emotion? If yes, click on "menu," click on "image," click on "mode," then go to "lab color." Next, go to the window menu and click on "channels." When the "channels" window opens, click on the "A" channel and drag the image into the garbage can.

Next, do the same thing with the "Alpha 2" channel. You've now discarded the color and have a black-and-white image. Go to the toolbar and click on "image," then "mode," then click "grayscale," then "RGB" (for Red, Green, Blue spectrum) to convert the photo to a tonal black-and-white image.

<div style="text-align:right">

Shoot in color and manipulate the images—then determine if they work better in black and white.

</div>

The RGB Range

The RGB image you get when you convert a color image to black and white in Photoshop is made up of three black-and-white channels—red, green, and blue. Using the Channel Mixer in Photoshop, you can adjust the red, green, and blue channels to vary the tone and contrast of the image. Colors close to those of each channel will appear lighter, increasing or decreasing the contrast between them and other tones.

Now it's time to refine the image with a little dodging and burning. At this point you've decided which areas you want to lighten or darken. Go to the toolbar and select the lasso tool. Take the lasso and draw a rough outline (it doesn't need to be exact) around the area you want to burn or dodge, making sure you are "feathering" the area so there's not an overly defined line. Once you've lassoed the area in question, hit the control key and L on a PC and the Apple key and L on a Mac and lighten or darken this specific area using the center slider. Deselect when you're done and assess the quality of this new image. The process of converting images to black and white is also very effectively accomplished using nik multimedia filters.

Black-and-white photography may be more effective today than it was back in the days when it was the only medium! Black-and-white images are all about pure emotion.

28–70MM LENS SHOT AT 65MM, 1/125 @ f2.8, ISO 200, EXP: AV, PHOTOSHOP BLACK AND WHITE CONVERSION

As an alternative to making black-and-white conversions in Photoshop, we use the nik multimedia Black and White filter, which produces high-quality monochrome conversions.

TOP: 85MM LENS, 1/200 @ f.5.0, ISO 200; EXP: AV

ABOVE: 85MM LENS, 1/200 @ f.5.0, ISO 200; EXP: AV; NIK MULTIMEDIA FILTER: BLACK AND WHITE

RIGHT: Scene setters are a necessity in a wedding album, but you might have to do a little work to make the image more interesting. We processed this image with software to add a black-and-white infrared effect but used a color background later to accentuate the dramatic banners.

28–70MM LENS SHOT AT 28MM; 1/1000 @ f5.6; ISO 500; EXP: AV; NIK MULTIMEDIA FILTER: INFRARED: BLACK AND WHITE, WITH COLOR BACKGROUND LAYER

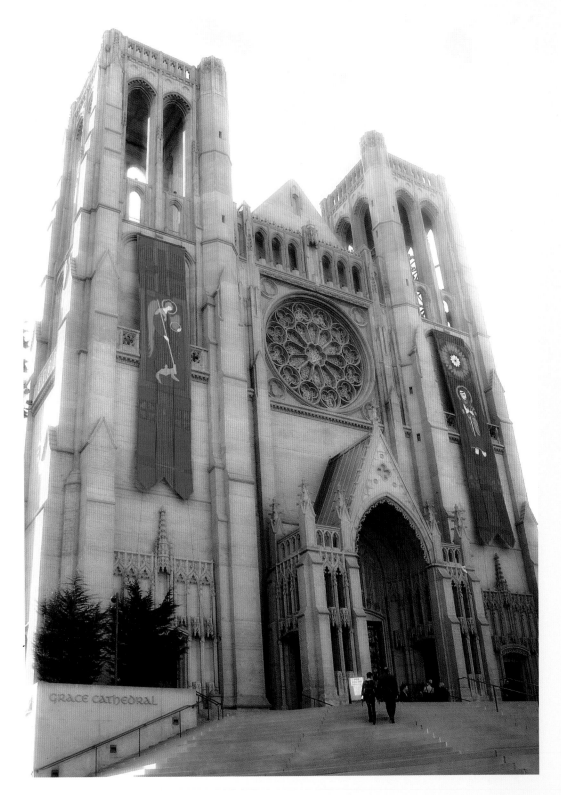

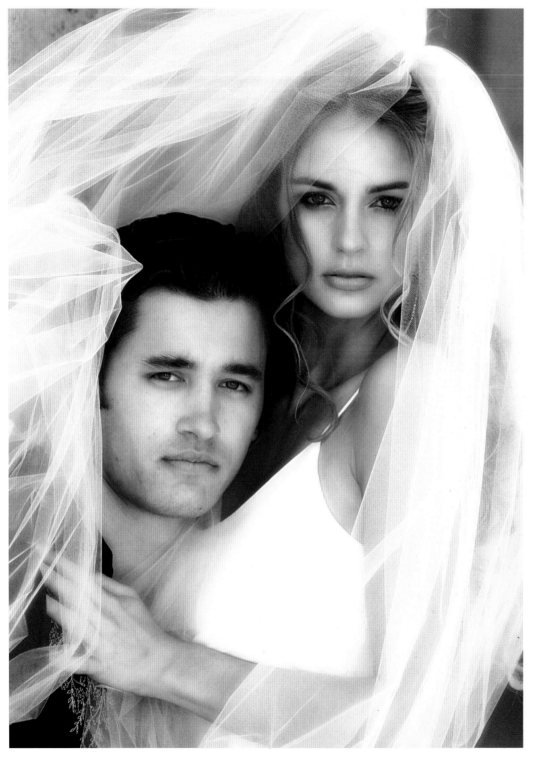

Fine-Tuning Images

Levels and Curves are digital tools that help you make adjustments to the contrast in the images you convert to black and white. In Levels controls, a histogram appears—this is a graph that shows exposure value in an image. You can move indicators on the graph to adjust the overall contrast of the image. The Curves control also includes a graph. You can adjust the position of an indicator on the line that runs diagonally through the graph to increase or decrease contrast.

70–200MM LENS SHOT AT 140MM, 1/399 @ f5.0, ISO 200; EXP: AV; CONVERSION TO BLACK AND WHITE

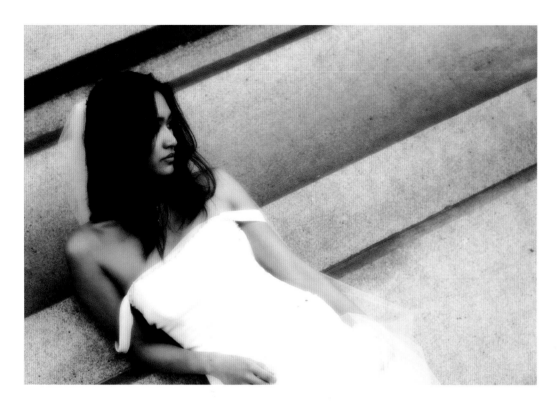

These shots show just what a stunning effect a carefully applied filter can have on an image. You need a strong visual to begin with, but a filter can transform a good shot into a great shot!

LEFT: 70–200MM LENS SHOT AT 200MM, 1/160 @ f2.8, ISO 200; EXP: AV, NIK MULTIMEDIA FILTER: DUPLEX

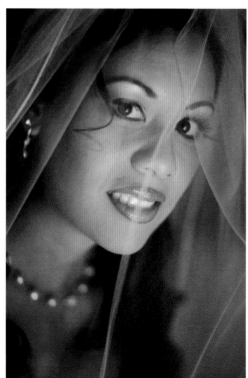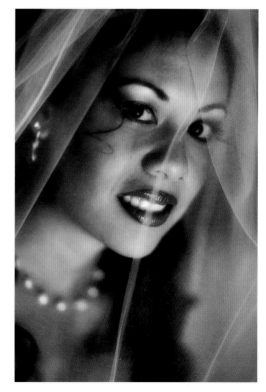

RIGHT: 85MM LENS, 1/200 @ f1.2, ISO 400; EXP: AV

FAR RIGHT: 85MM LENS, 1/200 @ f1.2, ISO 400; EXP: AV; NIK MULTIMEDIA FILTER: MIDNIGHT

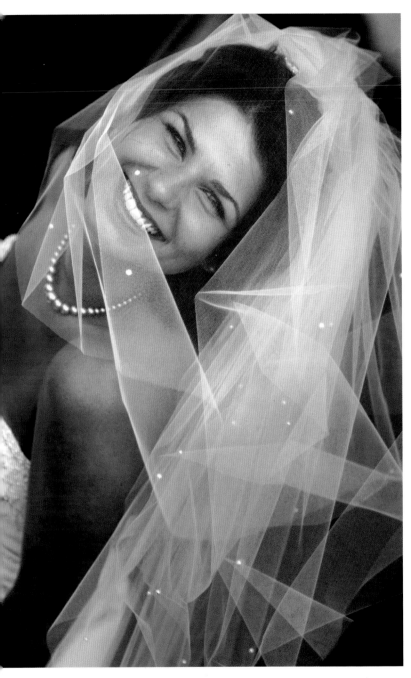

28-70MM LENS SHOT AT 70MM, 1/60 @ f2.8, ISO 200

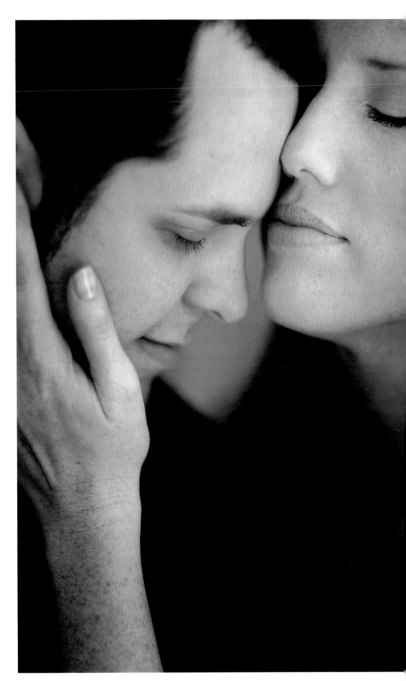

85MM LENS, 1/60 @ f1.8, ISO 100; BLACK AND WHITE CONVERSION

CROSS-PROCESSING

The concept of cross-processing comes out of the commercial world of professional

All of the colors shift, and the results can be extraordinary.

photography. When working with film, you cross-process by shooting on transparency film that the lab processes in C41, as if it were print film. All of the colors shift, and the results can be extraordinary: Images have a high-fashion illustrative look that can drive even the finest lab to tears trying to figure out what you were doing!

To cross-process in digital, simply capture the image as you normally would and then cross-process in Photoshop. One way is to use Curves controls, which allow you to vary tonal values in an image using a graph in the Curves dialogue box. Or, you can use Levels controls to adjust contrast up to 45 percent. The easiest way to get a cross-processed effect is to do what we do, use the Cross-Processing filter in nik multimedia. Like any other special effect, though, use cross-processing in small doses.

RIGHT: 28MM LENS, 1/15 @ f2.8, ISO 400; CROSS PROCESS

OPPOSITE: 70–200MM LENS SHOT AT 200MM, 1/1000 @ f2.8, ISO 200; EXP: AV; KEVIN KUBOTA CROSS PROCESS

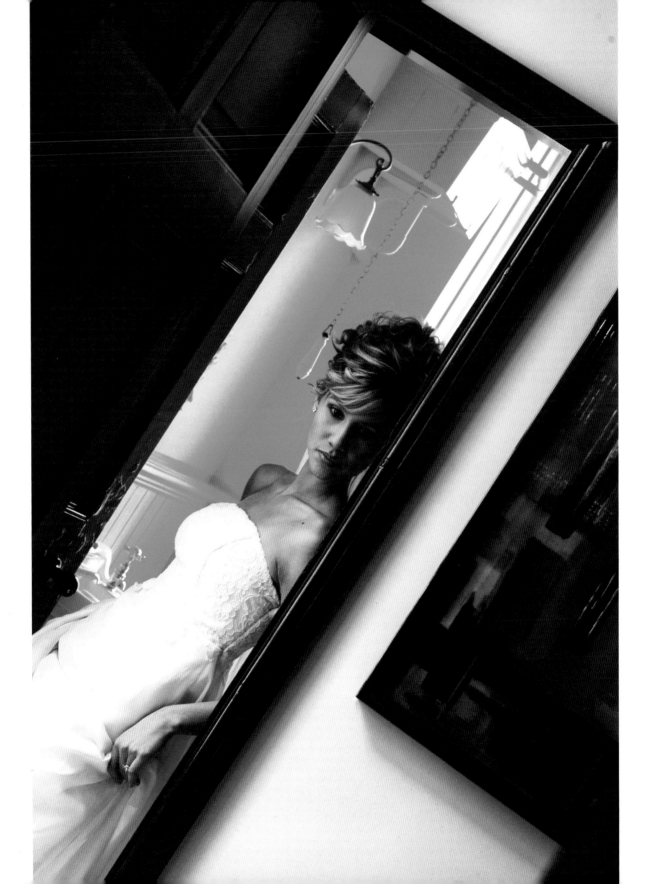

Cross-processing can create a stunning image in which the colors are heavily saturated. You don't want too many dramatic images like this in your album, but a few are standouts.

28–70MM LENS SHOT AT 28MM, 1/600 @ f5.6, ISO 200, EXP: AV; KEVIN KUBOTA CROSS PROCESSING ACTION

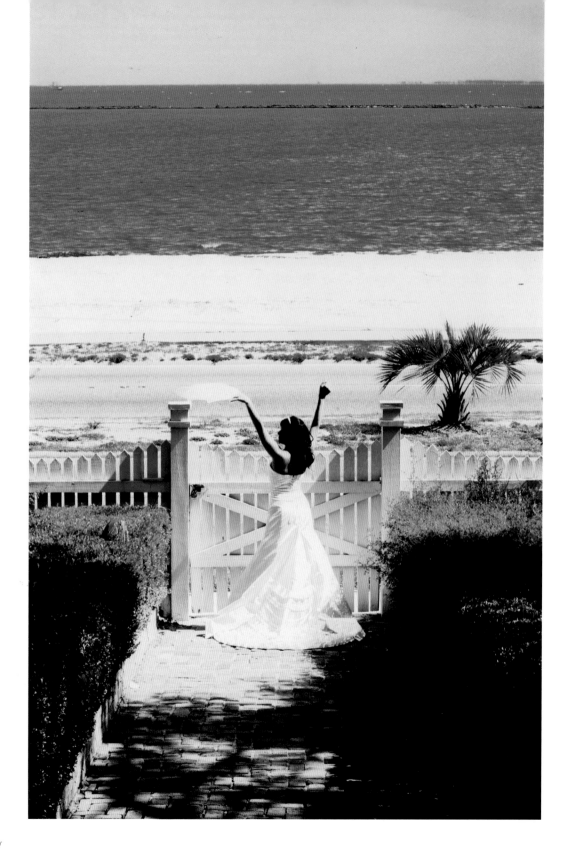

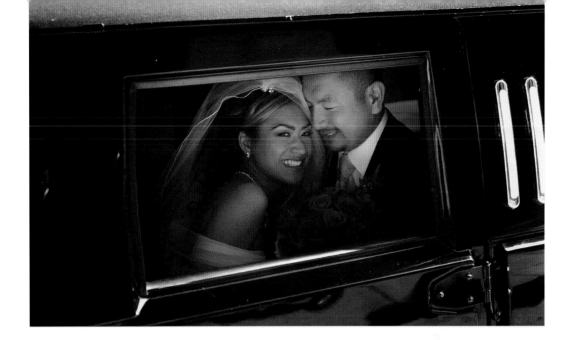

Usually, images that are best-suited to cross-processing are those that are less traditional. Cross-processing is the perfect complement to a little camera tilt and a less formal setting or pose.

LEFT: 28–70MM LENS SHOT AT 48MM, 1/80 @ f4.5, ISO 200; EXP: AV

BELOW: 28–70MM LENS SHOT AT 48MM, 1/80 @ f4.5, ISO 200; EXP: AV; NIK MULTIMEDIA FILTER: CROSS PROCESSING

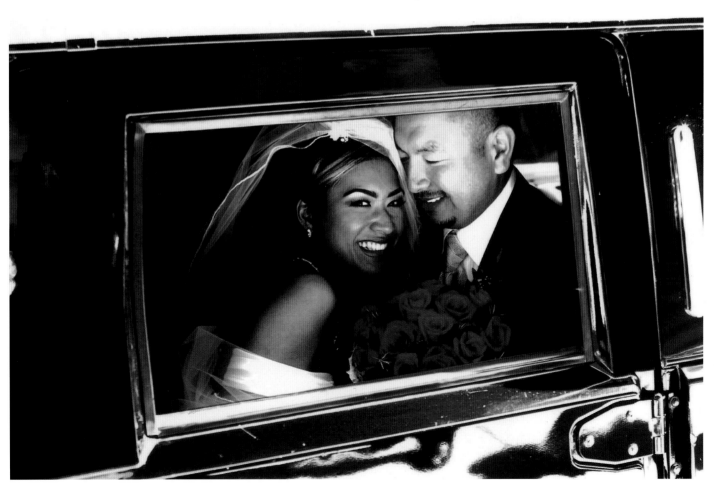

INFRARED

Infrared film and its digital counterpart, infrared filters, produce highly illustrative images.

However, infrared images are not just for the fashion-forward bride. Even the most conservative bride will love the results. Infrared adds an element of mystery to an image. The tones shift, and in so doing evoke a very specific mood—conservative, yet cutting edge.

The Infrared Effect

Infrared filters produce the same effects you would get with infrared film—that is, a dramatic, illustrative look. Since infrared film poses some limitations for wedding photography—it must be loaded and unloaded in complete darkness, for one—digital infrared filters are a godsend in that they help you get these effects more easily. Sliders and controls in the filter software allow you to control the overall lightness of the image, contrast, and luminosity highlights.

> Infrared adds an element of mystery to an image.

Same scene, different treatments. You could make the point that an image with such interesting lines and sense of movement (the effect of camera tilt) doesn't require added effects. On the other hand, a color infrared filter adds a sense of drama that's sure to wow.

RIGHT: 28–70MM LENS SHOT AT 35MM, 1/30 @ f2.8, ISO 100; EXP: AV

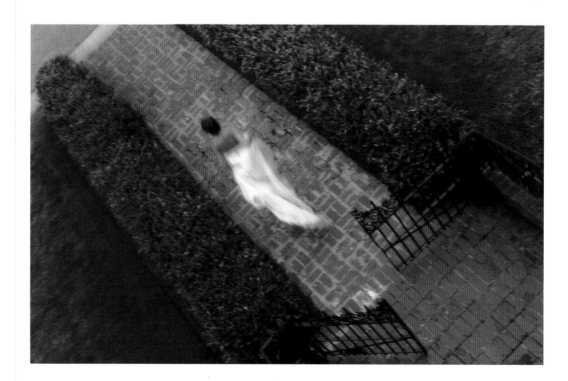

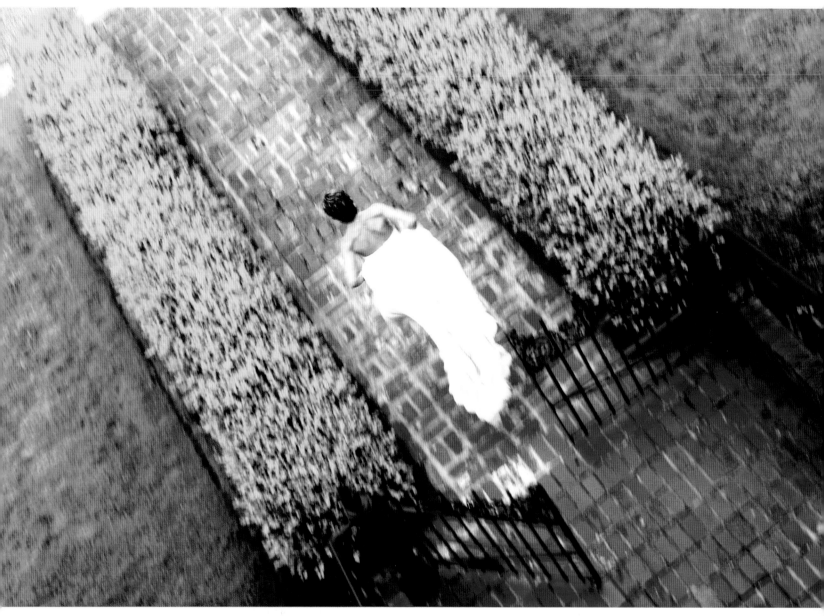

28–70MM LENS SHOT AT 35MM, 1/15 @ f2.8, ISO 200; EXP: AV; NIK MULTIMEDIA FILTER: INFRARED: COLOR

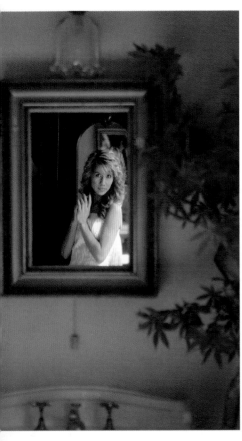

An Infrared filter tames some of the distracting bright spots in the original color image, and creates a wispy effect with the folds of the flowing gown.

ABOVE: 200MM LENS, 1/15 @ f2.8, ISO 400; EXP: AV

RIGHT: 200MM LENS, 1/15 @ f2.8, ISO 400, NIK MULTIMEDIA FILTER: INFARED

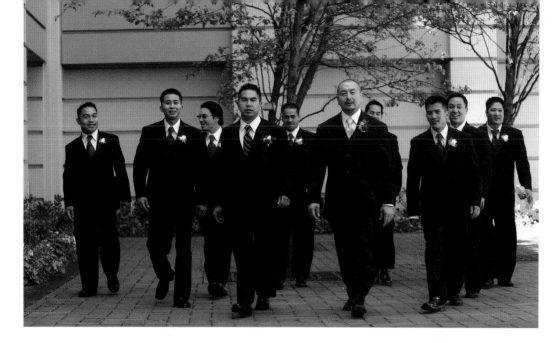

A shot of the groom and his army of groomsmen is interesting in the color version, simply because there are so many men in the party. But the infrared image is much more dramatic, and the rather dull background takes on a strong graphic quality.

LEFT: 70MM LENS SHOT AT 70MM, 1/200 @ f4.0, ISO 200; EXP: AV

BELOW: 28–70MM LENS SHOT AT 70MM, 1/200 @ f4.0, ISO 200; EXP: AV; NIK MULTIMEDIA FILTER: INFRARED

OTHER FILTERS

When you are comfortable with the digital medium and ready to mix and match the various effects, the fun really begins. With digital manipulation, there are no limits to what you can do with an image. At times it's tempting to become a filter junkie, but be careful when you're creating the final album. Use special effects sparingly and don't overdo. Your primary responsibility is to tell the story accurately and in a manner consistent with the bride and groom's tastes. Filters and special effects help you add a certain mood to your images and give them a stronger fine-art feel, but they can't make up for real emotion if you missed a decisive moment!

Filters can't make up for real emotion if you missed a decisive moment!

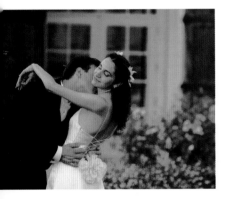

The Monday Morning filter diffuses light in an image, creating a soft, slightly blurry effect. In this case the filter saves the original image from washout.

ABOVE: 70–200MM LENS SHOT AT 125MM, 1/60 @ f2.8, ISO 200; EXP: AV

RIGHT: 70–200MM LENS SHOT AT 125MM, 1/60 @ f2.8, ISO 200; EXP: AV; NIK MULTIMEDIA FILTER: MONDAY MORNING

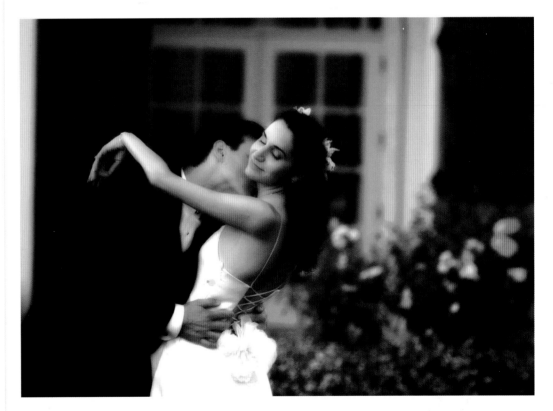

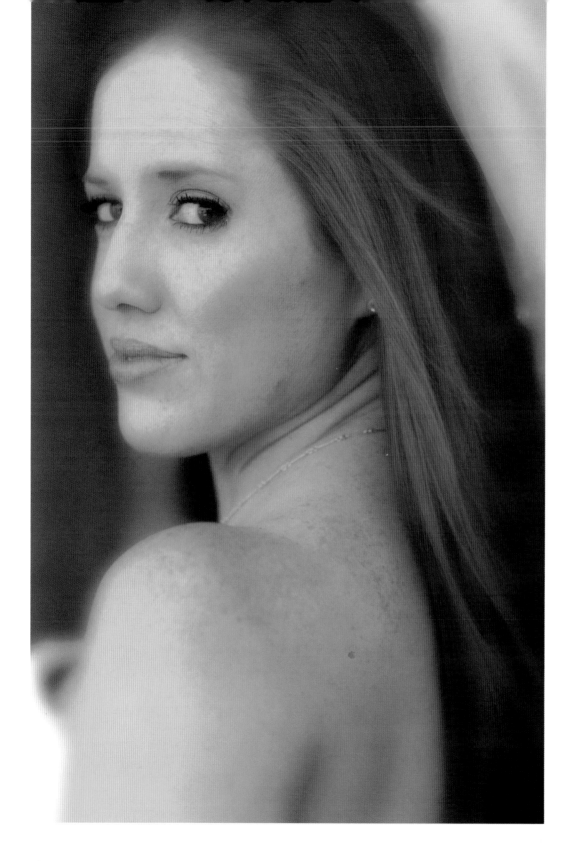

Certain scenes lend themselves well to treatment with specific filters. Here a Soft Focus Filter provides just the right mood.

28–70MM LENS SHOT AT 34MM, 1/160 @ f2.8, ISO 400; EXP: AV; NIK MULTIMEDIA FILTER: SOFT FOCUS

While the staircase adds a nice structural element to this image, the colors are a bit bland, with a lot of washout. So, we gave it a double whammy—the nik multimedia Saturation to Brightness filter accentuates the colors, while a Photoshop Dark Strokes filter sharpens the edges.

RIGHT: 28–70MM LENS SHOT AT 28MM, 1/160 @ f5.0, ISO 200; EXP: AV

BELOW: 28–70MM LENS SHOT AT 28MM, 1/160 @ f5.0, ISO 200; EXP: AV; NIK MULTIMEDIA FILTER: SATURATION TO BRIGHTNESS AND PHOTOSHOP: DARK STROKES

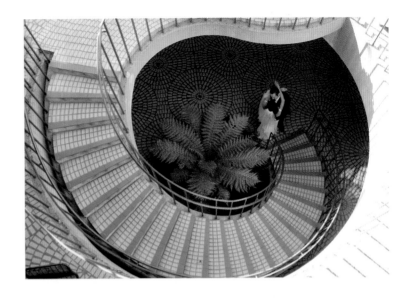

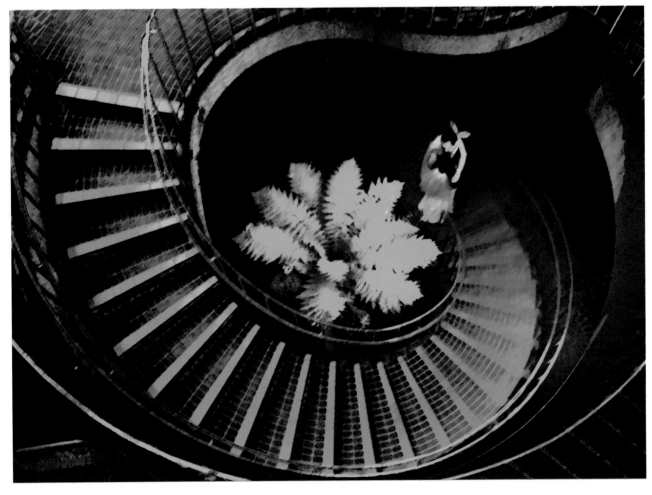

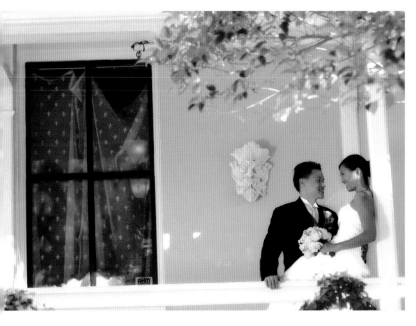

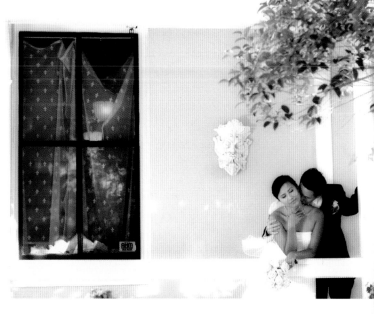

Different filters, different effects:
By treating similar scenes slightly
differently, you evoke different
moods and get a much greater
variety of images.

TOP LEFT: 85MM LENS, 1/640 @ f3.2,
ISO 200; EXP: AV; NIK MULTIMEDIA
FILTER: SUNSHINE

ABOVE: 85MM LENS, 1/640 @ f3.2,
ISO 200; EXP: AV; NIK MULTIMEDIA
FILTER: DUPLEX

LEFT: 85MM LENS, 1/640 @ f3.2,
ISO 200; EXP: AV; NIK MULTIMEDIA
FILTER: SUNSHINE

The resulting image is not for everyone, but a Saturation to Brightness filter turns an ordinary shot of a couple into a candidate for an arty engagement shot. This filter exaggerates colors (notice how the reds and greens pop) and highlights structure and shape.

ABOVE: 70–200MM LENS SHOT AT 70MM, 1/3200 @ f2.8, ISO 200; EXP: AV

RIGHT: 70–200MM LENS SHOT AT 70MM, 1/3200 @ f2.8, ISO 200; EXP: AV; NIK MULTIMEDIA FILTER: SATURATION TO BRIGHTNESS

Engagement photos are a good arena in which to experiment with special effects. Camera tilt adds a sense of motion to this image, and the Accented Edges filter turns the photo into a colorful illustration. One or two of these images can be fun additions to an album, but you definitely don't want to overdo them.

LEFT: 70–200MM LENS SHOT AT 170MM, 1/25 @ f5.0, ISO 200; EXP: AV

BELOW: 70–200MM LENS SHOT AT 170MM, 1/25 @ f5.0, ISO 200; EXP: AV; PHOTOSHOP FILTER: ACCENTED EDGES

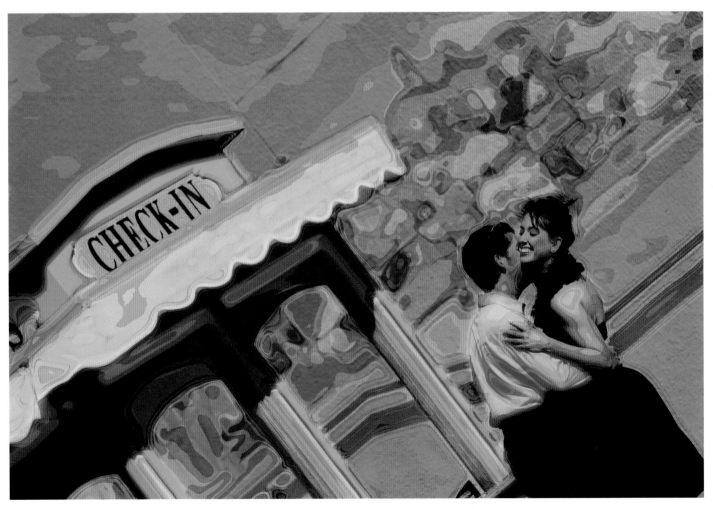

Get creative with filters and special effects to render different versions of the same image. Play around and compare the results.

Here are some examples of what we can create using different filters or combinations of special effects on the same image. As you see, filters can completely change the mood of any image.

FOR ALL: 200MM LENS, 1/15 @ f2.8, ISP 200

ABOVE: AS SHOT

SATURATION TO BRIGHTNESS

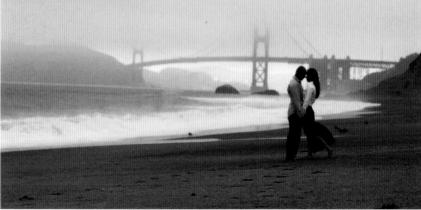

COLOR STYLIZER

NIK MULTIMEDIA FEATURE: DUPLEX

POP ART

MIDNIGHT BLUE

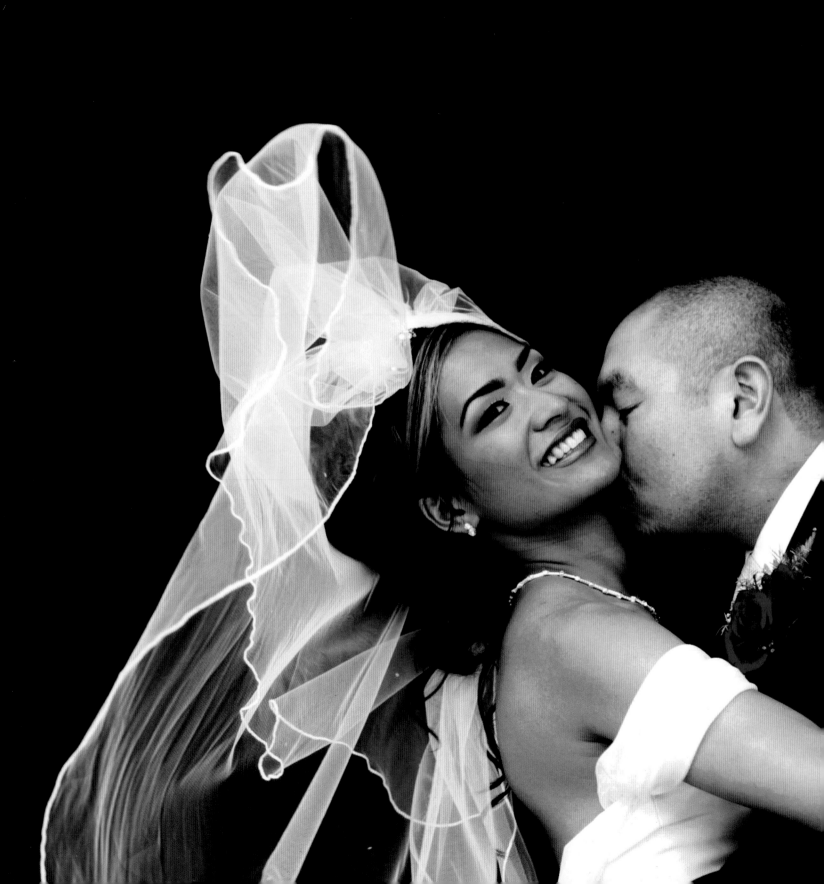

TIME TO DELIVER

ONLINE HOSTING

CREATING THE ALBUM

You've processed the images. Now the task is to show them off in ways that are as unique as the couple who hired you to capture the magic of the first day of their life together.

ONLINE HOSTING

It only stands to reason: The quicker you can deliver images to your clients, the more enthusiastic they will be to buy prints. Remember, good marketing is all about "striking while the iron's hot," and the iron is going to be hotter a few days or weeks after the wedding than it will be a month later.

The best way we've found to deliver images quickly is to use an online hosting company—in this case, modern technology is a great tool for building client relationships. Our favorite is www.eventpix.com. This software is easy for both the photographer and the client to use, and it allows you to send the client a great presentation. Keep in mind, though, that the most sophisticated software is not going to replace what you alone can provide, a sense of what your client will want. If you're not in step with your clients' mind-sets and don't supply what they want, beware: The most subdued, polite client can become a howling monster when shielded by the anonymity of a computer screen.

We make it a point to call our clients and tell them we have posted their images to the internet. This is a perfect opportunity to touch base with your client, and what could be more enjoyable than telling a bride that images of her wedding are available for viewing? We strongly suggest that you don't leave a message with the groom. In every study we've ever seen on buying habits in professional photography, the woman makes the decisions. This is the bride's moment.

The most subdued, polite client can become a howling monster when shielded by the anonymity of a computer screen.

We use Eventpix for online hosting. At the same time we send a disk to our lab, we upload images to this online service. It only takes about half an hour to upload the 600 to 800 images we take at a typical wedding.

Be a Ruthless Editor

Remember, the number one difference between amateurs and professionals is that amateurs show you all of their shots! Your client is going to be more impressed with quality images and not with how many you actually took. If somebody blinked, for example, dump the shot—it ain't gonna sell.

SHARING THE IMAGES

When we call the bride and tell her we've posted the images, we also ask her if she is happy sharing the images with her family and friends. This is an easy process. Guests and other interested parties simply go to the Eventpix site and enter a password to view the images.

Usually, the bride will send the password around. Or, when users go to the Eventpix site and locate the event, they are instructed to e-mail the photographer for the password.

Eventpix becomes a PR machine for you as family members and guests access all the images you captured at the event and order the ones they want. How many times have you been a guest at a wedding and had your photograph taken? Now, how many times have you ever seen that image? Rarely, probably. The bride isn't going to spend money to get you a copy of that shot, and you're not going to ask the bride to get you a print. You probably don't know the name and address of the photographer. As a result, millions of images simply disappear or never make it beyond a proofing album.

Some Dos and Don'ts of Online Hosting

- Don't communicate with your client via e-mail. Communicate via paper, with your signature affixed. This approach is friendlier and more professional, and helps protect you legally should the need ever arise. Besides, a lot of people don't read their e-mail regularly. And never write anything to a client in an e-mail that you're not willing to share with the world!

- Don't assume people are on the same broadband system you are—that is, that they can easily accept large photo files. Less than half of households with internet access use broadband, which means that more than half don't.

- If you're going to share a few advance images with your clients, don't send them high-resolution files. It will take your clients far too long to download these.

ABOVE LEFT: On Eventpix we set up the same categories we use to store the images on our computer and DVDs: We simply take images in each category and drag them into the matching category on Eventpix. It's a process a six-year-old could handle!

ABOVE RIGHT: Guests can order images that appear on the Eventpix site directly from you. If you did a good job covering the event the images are going to sell themselves!

Storing Images

As you become comfortable with digital technology you'll discover dozens of shortcuts for organizing and storing images from the weddings you shoot. After a wedding, we have images on the original CompactFlash cards, on the DVDs our assistant burns during the event, on our mainframe computer, and on two DVDs—one we've sent to the lab to process prints and the other we keep in the client's folder. We soon reformat the CompactFlash cards so we can reuse them. While many photographers see no need to keep images on the mainframe, we continue to store all the events we shoot on a separate hard drive organized by year. This makes it easy to access files and find virtually any image a client needs.

To Proof or Not to Proof

We've found people still like to hold images in their hands—and are willing to pay a premium for them. They like to view images at times when they don't have access to a computer. The bride is going to be showing those proofs all over the place, and they're going to create additional sales. We're not worried about the client infringing on our copyright and making copies, because we've been fairly compensated for our talent and skills up front.

Then there's the packaging issue. From companies like Godiva, Armani, Gucci, and Tiffany's we've learned that the value of a product is enhanced by the package it comes in. We're constantly hearing stories of photographers who deliver proofs in a plain brown wrapper that generates all the excitement of a carton of eggs! Give your images the presentation they deserve and spend the money on professional packaging. Your clients hired you because you convinced them you were unique. Here's a chance to instill confidence that you provide quality that sets you apart from your competition.

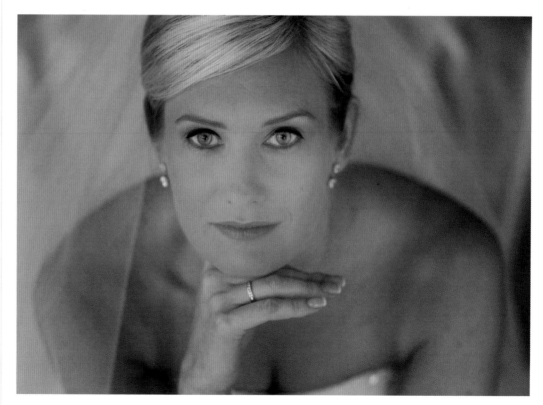

85MM LENS, 1/640 @ f2.2, ISO 200; EXP: AV; PHOTOSHOP CONVERSION TO BLACK AND WHITE

CREATING THE ALBUM

Photographers have access to a fine and ever-increasing selection of album designs, from black to every color in the rainbow; from leather to vinyl to wood to every conceivable fabric; from full-page bleeds to bordered page mounts; to stainless steel and glass. Yet, even with all the choices, one standard remains constant: No matter how many DVDs, video tapes, and framed prints are available, the bride still wants a tangible heirloom, her wedding album. That album needs to tell a comprehensive story and include a mix of black and white and color together with a mix of formal images and photojournalism that captures the human experience. Our average album is going to have seventy-five photographs on forty to fifty pages.

The process starts when clients pick out as many images as they'd like to include. Don't worry about how many images the clients choose: Let them make their choices, then be creative in making the images fit; we have a flat surcharge for each page we need to add to accommodate extra images. No matter how many images you use, you should always follow the sequence of the wedding day. Another hard-and-fast rule is to provide a mixture of different-size images and varied layouts. You might have a double-page panorama followed by smaller images spread over two pages. The point is to tell the story of the day in a compelling way.

One standard remains constant: The bride still wants a tangible heirloom, her wedding album.

Making It Easier to Choose

Giving clients the ability to pick all the images they like rather than a fixed number resolves two key issues photographers have been crying about for years. First, it speeds up the selection process. If the bride can simply pick any image she likes things will move along a lot faster than they will if she's forced to make a choice between images. Remember, she's already overwhelmed at the quality and diversity of the images you've sent her. Second, if you force the client to pick a specific amount, you limit your own creativity as well. You also generate a certain amount of "ill will" over the process.

PIECING IT ALL TOGETHER

Step One: Choose the album-design software you want to use. We recommend Yervant's Page Gallery software, which can be found at yervant.com, though many other software companies offer album-creation tools. Step Two: The clients return the proofs of the images they want to use in their album. We let them keep all the proofs, because we've built the cost of proofs into the pricing up front. If our clients have opted not to receive paper proofs, we send them images online and have them make their selections.

So, now you're set to go. Put the images in sequential order. Remember how you numbered all your images within each category when they went into your computer? All you need to do is go into those files and retrieve the images in order. Using the page-by-page design options available in whatever software you choose to use, drag and drop the image into the appropriate pages. When you've completed the layout, print out the entire album. We show six pages per sheet on our Epson printer (a page is a single side of an album) and use Epson matte photographic paper. We still want to present a quality product, even if it's only to show the album layout, so we bind the proof and use a hard card-stock cover and back.

70–200MM LENS SHOT AT 95MM, 1/500 @ f4.0, ISO 200; EXP: AV

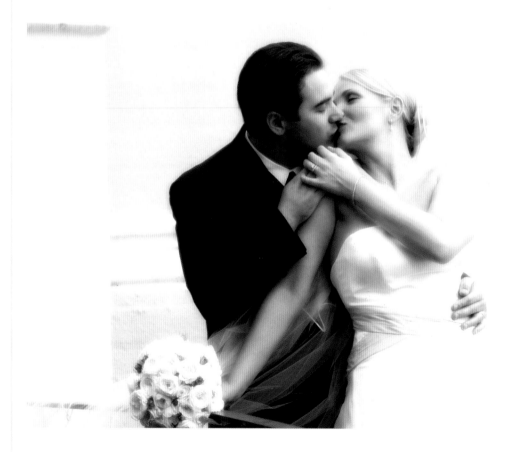

Once clients approve the album layout, we have them sign off on a postage-paid return card we've included with the package. When we receive the approval, we immediately burn a CD or upload the images to the Web and send them to the lab for printing. When the pages or prints come back from the lab, we assemble the album to match the layout we've designed, then send the pages to the album company for binding. Producing the typical album takes nine to twelve weeks from the time the client approves the prints.

CREATING THE ALBUM WITHOUT CLIENT INTERFACE

What if you could speed up the entire process and deliver a completed album when you send the bride her proofs? We've just started to experiment with this concept and we love it.

We create the entire album without any input from the bride. With her proofs she receives a fifty-page album we've designed to tell the story of her special day. By doing this, we remove all the stress of trying to decide which images to choose. Besides, who can better tell the story of the day than the photographer who captured the event?

Photographers panic when they first hear this idea. What happens if a bride doesn't like what we've done? First, she's usually so overwhelmed by the way we've told the story, this just doesn't happen. Second, if she's not happy with a few images or we left out some she likes, she can make changes—from the start we make it clear that she's allowed up to five changes at no extra charge. And third, there's a big advantage to this process that's hard to resist: We can deliver an album four to six weeks after the wedding!

Striving for Uniqueness

Every album should be as unique as your clients are. To create the first heirloom of a new family:

- Let the images tell the story of the day as it unfolded.
- Mix up your photographic techniques appropriately.
- Don't overdo special effects. You only need a few images with camera tilt, and a couple of hand-colored images.
- Mix up those tight-face shots that capture emotion with wider-angle images of the event itself. Remember, you're telling a story here and there's no better way to capture it than with facial expressions. A double-page panoramic is great, but do only one and put it in a logical place in the story. You don't have to use it in the first two pages or the last two pages of the album.
- Don't overdo funky designs. A collage of images on one page might be an appropriately fun touch for some clients, but if you do too many of them the album is going to look like a high school yearbook.

Design Like a Pro

Unless you have a degree in graphic design, don't try and design pages yourself. It takes too much time and you're missing one of the greatest assets of our industry, the YZ factor! The YZ factor is a collection of pre-designed templates by one of the finest wedding photographers in the world, Yervant Zanazanian. These templates give every wedding album the look of a customized book and make the photographer seem like a hero every time!

Too often photographers forget
the potential for images during an
engagement session. When the
final album is completed, what
better place to start the story
than with one of the very first
images ever captured?

Kathy and Ron
June 21, 2003

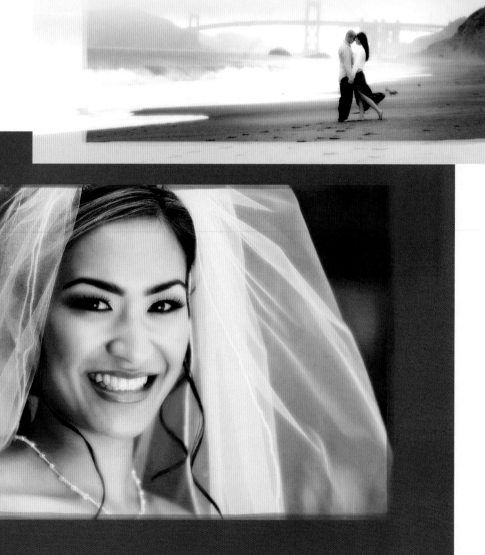

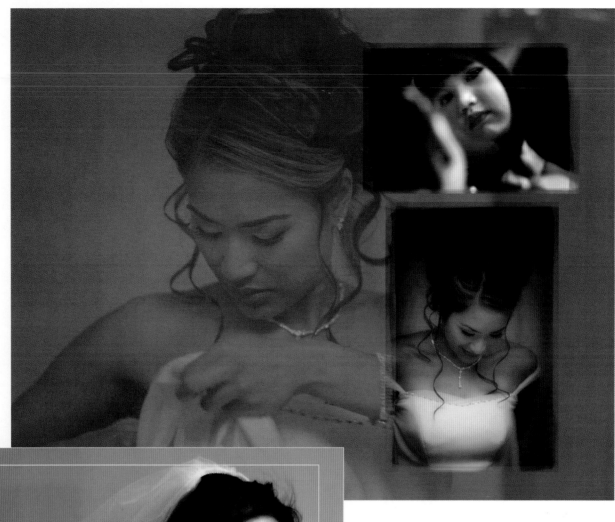

© DAVID ANTHONY WILLIAMS

Look for isolated elements that help to tell the story of the bride's preparation for the big event. When creating the layout, avoid putting too much on one page and stay away from too many special effects that will make the page too busy, distracting from the quality of the images.

The groom is just as important as the bride when it comes to what images to include in the final album. Try to capture the essence of the groom with dynamic lighting, expressions or cropping.

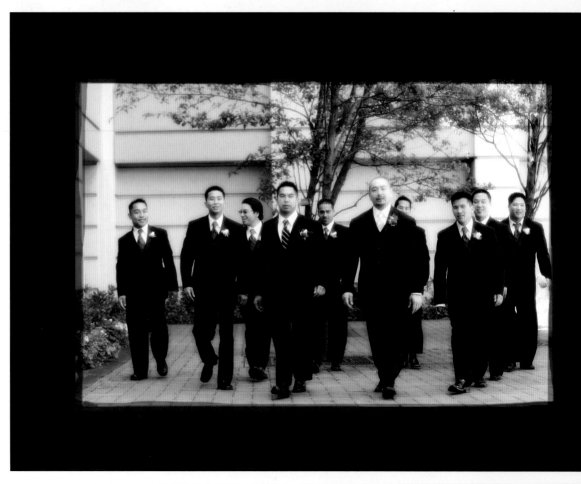

Every important image has a series of sub-images, additional details that help to tell more about the event or the subjects. On each page look for ways to bring together images that are key elements of the story you're trying to tell.

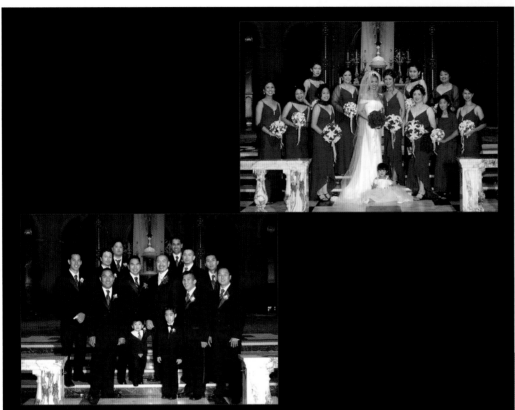

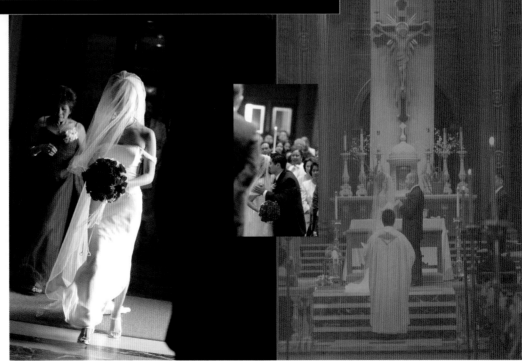

ABOVE: Pay attention to how you pose your groups. Work in triangles of three people at a time, being careful not to position everyone on the same plane.

RIGHT: Digital imaging, with the help of Photoshop, gives you maximum creativity in designing the pages of your album. Be careful, though: Use too many special effects in an album and you'll be like the cook who uses too much garlic—you'll spoil the whole effect!

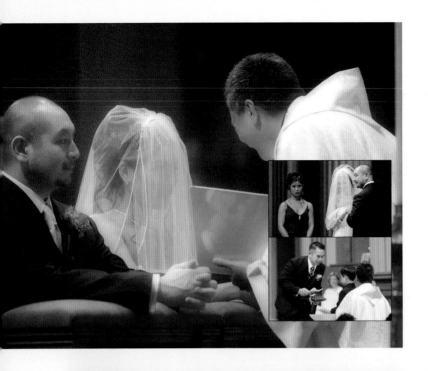

Each page of the album should look unique, but it's still a component of the story. Sometimes two smaller images by themselves have more impact than one full-page image.

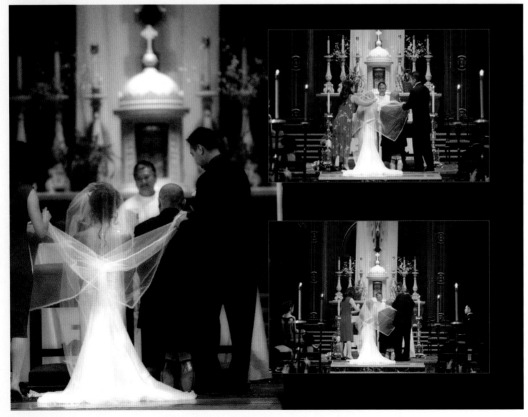

You don't have to fill up every
page completely to give your
story high impact.

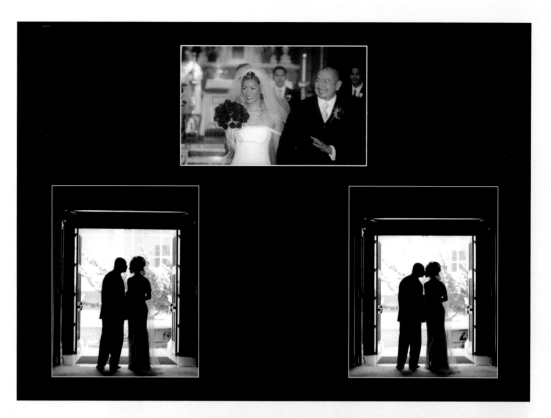

Remember, you're a graphic designer when it comes to putting together the final album. A relatively traditional image can suddenly have high impact when you add a few non-photographic design elements to the presentation.

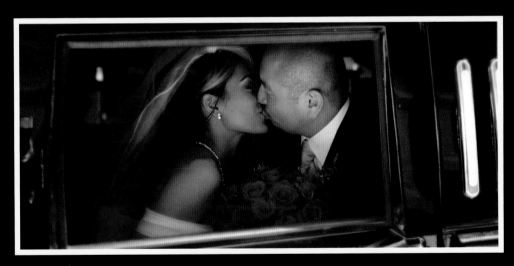

A wedding is all about people, but you can't show everyone who attends. This is where getting to know your bride and groom becomes so important. When creating the final album you want to be sure and include images of family and friends who are important to them.

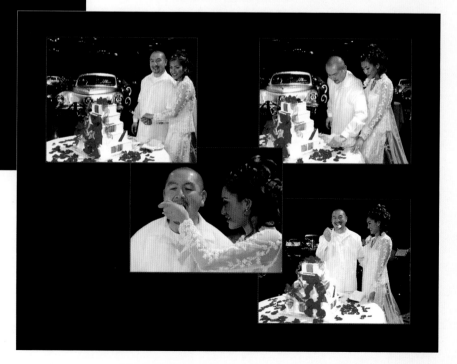

Every wedding, no matter what the culture, has one element of tradition. It's important to make sure it's a part of the final album. Then, like any good storyteller, look for the ideal final image that closes the first story about the start of a brand new family.

WEB SITES THAT SELL

You can't be in the wedding photography business these days unless you have a Web site. That is, a great Web site. Like it or not, people do judge a book by it's cover. A Web site is your calling card, and if it's well done, your strongest tool for creating more business. On the other hand, a Web site that is slow to view, is a nightmare of mediocre images, and contains only minimal information is a real liability. Here are our twelve rules for creating a Web site that sells.

Rule 1: Hire a pro! Unless you are a graphic designer and well versed in computer graphics and Web design, don't try and build your site yourself. Hire a professional and treat your designer with the same respect you show your attorney and your accountant.

This home page from Bambi's Web site uses flash technology and scrolls through a series of her best images.

Rule 2: Don't exceed two clicks! This is the maximum effort it should take to get to the most important information on your site: your gallery, your contact information, and your pricing.

Rule 3: Put your ego away! Since there's no such thing as a bad reference, leave out the quotes from satisfied clients and a personal bio that puts you ahead of the Pope. It's your images that will excite your clients—not a lot of hype about who you are.

Rule 4: Be printer friendly. Black pages with white type look great artistically, but what happens when your future clients go to print them out? The process takes forever, and they'll end up with ugly wet black sheets that have sucked up the last of the ink! Instead, keep it simple. Your contact page, especially, should be simply designed, and the information should print in black on white paper.

Rule 5: Test your site on an analog line. Many people still use dial-up modems, and you should be aware of how long it will take your images to load for them. If the process is too slow, your customers will lose interest before they ever get to the images you want them to see.

Rule 6: Don't share an average image. We've noticed that some of the finest photographers in the country put boring and mundane images on their Web sites. They've opted for quantity rather than quality. Images that put you to sleep will send your potential clients running to another photographer's Web site.

Rule 7: Proofread! Read all the information on your site out loud and, by all means, have someone else read everything on your site as well.

Rule 8: Show diversity in your work. You want images that are so interesting the consumer can't wait to hit the next thumbnail to view more of your work. Show color, black and white, infrared, hand coloring, camera tilt, narrow depth of field, group shots, tight-face shots, kids, adults, details—you don't need a lot of images, but you want potential clients to know there's nothing you can't photograph. Start out with some high impact close-ups to get attention. A thumbnail of the Rocky Mountains with two tiny pinheads in the bottom corner won't draw them in!

Rule 9: Give people easy ways to contact you. Give a phone number as well as e-mail and regular mail addresses.

Rule 10: Check your Web site at different screen settings. Don't assume everyone uses the same monitor settings you do. Too often the best information on a photographer's Web site appears below the fold (the bottom of the screen).

Rule 11: Test your site at least once a week. Just because the site worked great last week doesn't mean gremlins haven't changed the rules. Ask a couple of close friends on other browsers to check the site for you, too.

Rule 12: Pay attention to what's going on in commercial bridal photography and use this information to select the types of images you put on your Web site. Images in high-profile ads influence trends in the market and push consumers' hot buttons. Pick up a copy of any good bridal magazine and look at the types of images being shown in the ads and editorial. What types of photography are companies like Armani, Vera Wang, Amsale, and Monique Lhuillier using in their ads? Are the images shown in editorial, color, or black and white? Are they tight detail shots or wide-angle landscapes?

As we see it, wedding photography is, quite simply, great fun. After all, think about what being a wedding photographer is all about. We get to capture some of the most important moments in our clients' lives through the lenses of our cameras. We get to know our clients and see the wedding not just through their eyes, but through their hearts. We not only get to be creative, but we owe it to our clients to be creative. When all is said and done, being a wedding photographer means capturing the celebration of a couple's new life together. And if that's not rewarding, and downright fun, what is?

70–200MM LENS SHOT AT 110MM, 1/15 @ f2.8, ISO 400; EXP: AV; NIK MULTIMEDIA FILTER: SATURATION TO BRIGHTNESS

INDEX